John Spencer was born in 1925
and educated at Wimbledon School of Art,
Reading University, the Courtauld Institute and Manchester
University, where he was awarded his Ph.D. in 1984. Widely experienced
in teaching art and art history in schools, universities and colleges
of further and adult education, he was Chief Examiner of
A-Level history of art for the University of London Examinations
and Assessment Council (ULEAC)
from 1982 to 1994.

the art history study guide

John Spencer

With 120 illustrations

 Thames and Hudson

Acknowledgments

I would like to thank the following: Don Cupitt and the SCM Press for permission to quote from *Creation out of Nothing* (1990); Mr Graham M. Ward of R. Griggs Group Limited for helpful information about their Dr Martens 'Air Wair' products; Thames and Hudson for permission to quote from H.D. Molesworth, *European Sculpture* (1965); Keith Colley, Director, Metropolitan Home Ownership, for his helpful observations about twentieth-century building; the University of London Examinations and Assessment Council; and Dr M.I. Waley, Curator for Persian and Turkish Section, British Library. Above all, I would like to thank my wife Shirley for reading the present work in manuscript and for making many helpful suggestions.

British Library Cataloguing-in-Publication Data
A catalogue record for this book is available from the British Library

ISBN 0-500-27878-4

Printed and bound in Slovenia by Mladinska Knjiga

Contents

How to Use This Book

This book draws extensively on the teaching of art history in the United Kingdom. It is written primarily as a guide for A-Level and adult education students in the United Kingdom, but is intended to be useful to students and art-enthusiasts throughout the world. Because it has been designed to meet a range of educational requirements, a little guidance may be necessary to help you find the information you need.

There is no reason to start at the beginning of the book. Turn to the Contents page. Students will have a variety of needs and should begin (at least) by looking for what particularly interests them. Although the material dealt with in Chapter 4 may seem familiar to some, it should be regarded as providing a key to the approach adopted elsewhere. Similarly, the section called 'Levels of Understanding' on pp. 48–51 in Chapter 7 is central. Chapter 8 is in some ways the heart of the book and should not be omitted – though it may be best to take it in stages!

The following general guidelines might prove helpful:

- **Those considering whether or not to study the history of art at any level should read the Introduction and Chapter 1**

- **Those committed to A-Level history of art should begin with Chapter 1 but may be selective in their approach to Chapters 2 and 5**

- **Those wondering which A-Level GCE board to work with should study Appendices II and III**

- **Those committed to practical art and design courses at any level should start with Chapters 1, 2, 5, 8 and 9**

- **Those studying the history of art as part of a joint degree or as adult education students may well be more selective in their approach, but they should find food for thought and discussion in the Introduction, Chapters 4, 5, 6, 7, 8 and 9 and Appendix I**

- Those considering which periods in the history of art to specialize in should read Chapters 3 and 8 and look at Appendices II and III

- Those trying to decide on a topic for a dissertation should consult Appendix IV to find museums and sources of art-historical information in their area

- For a quick reminder of key points, see the summary Guidelines at the end of each chapter

Introduction

Having been involved with the teaching of art history at almost all levels, I have come to believe that the lines of demarcation between them are too firmly drawn. Whether we approach the subject at secondary, tertiary or adult level the governing principles remain very similar. The fundamental concern is much less with knowing facts for their own sake than with mastering how to use them profitably.

Such differences as exist between the levels are of two main kinds: those relating to the maturity of students and those that could be called 'cultural'. The maturity issue is the only one that poses a real difficulty. It involves differing degrees of general knowledge and literacy, matters that are usually (but by no means always) related to age. I have tried to avoid overuse of specialist words and phrases that are likely to give trouble, but it is hoped that where someone encounters difficulty he or she will consult a dictionary. Failing that, the student can put the matter 'on hold', pending a flood of insight later on!

The 'cultural' differences concern the way students are taught. Some study in groups where 'field work' is central. They visit relevant sites and galleries to look, experience, listen and question. Others meet in small groups and 'talk through' aspects of the subject, bringing matters out and clarifying them in terms of 'their own reality'. Most, however, will attend informal lectures illustrated with slides, while the lucky few will discuss the subject with their tutor on a one-to-one basis.

Some centres encourage one of these methods to the exclusion of the others, but it is hoped that the majority will combine one or more of them. In order that the approach adopted can be seen to have worked, all students will undergo some form of assessment, either ongoing or at the end of their course.

While this book might encourage some to embark on a degree course solely devoted to art history, it is not principally intended for that level. The present guide is mainly designed to help those who approach the subject with different but by no means inferior objectives.

First, there are those who wish to develop their practical work through a better knowledge of other artists and designers, whether living or belonging to the more or less distant past. They will also want to understand more about the nature and language of criticism. The needs of this group are catered for in the various practical A-Level, BTEC and GNVQ syllabuses and also in a number of compulsory

units associated with BA courses in art and design and others related to BEd and BA(QTS). Details of these can be found in the Appendices, beginning on p. 174.

There are also many who feel that they would like to pursue the history of art as a pure discipline but without wanting to commit themselves to a career wholly dependent on that subject. They may choose to keep their options open by associating art history with other disciplines at A-Level and perhaps by working with a joint degree in mind.

Another, perhaps larger, group study as adults through a university extramural department or classes organized by the WEA of a Local Education Authority. Many of these are short courses and only a few allow students to develop their interests in the context of an ongoing scheme. However, there are centres that offer certificates and diplomas in art history. In addition, students taking many of the shorter courses can earn transferable credits in Category 1 of the Credit Accumulation and Transfer Scheme (CATS). All of these qualifications are recognized by the Open University and an increasing number of other universities. If the present pattern of government funding for extramural education continues, this type of course is likely to become more common.

Taken on its own, the practical value of a qualification in the history of art is relatively limited. Apart from some specialized opportunities, such as the practice of connoisseurship, conservation, criticism, curatorship, dealing, publishing and restoration, for most people the objective seems to be teaching, lecturing and/or a research fellowship. Career prospects are greatly enhanced, however, if you consider various subject combinations. A coupling at secondary and/or tertiary level with art, architecture, dance, design, drama, environmental studies, engineering science, English literature, film studies, geography, history, media studies, music, philosophy, psychology, sociology, theatre studies and other subjects may suggest a much wider field where careers are concerned. One university is currently offering over sixty joint degree courses that include the study of art history.

There are also those who find that the study of art history needs no practical justification. Yet, without a structured course (and that usually means one with an examination at the end of it!), learning can lack focus. Those who set themselves

a definite target will find enrichment and renewal. They will also get a better understanding of their own cultural roots and those of others – important ingredients in the development of interpersonal and interracial harmony.

In common with most colleges and examining boards, in this book I include architecture as an integral part of the subject 'art and design'.

Guidelines

- **Choose a course that suits your habits of study and professional ambitions**

- **Look carefully at the available options – there are literally hundreds!**

- **Improve your career prospects by considering a joint degree course**

1 Why Turn a Pleasure into a Discipline?

The study of the history of art is often associated with 'art appreciation'. This pairing seems to imply that art is in its very essence something worthy of appreciation or even requiring unquestioning approval. Such an idea has been popular in various periods in history, but, frankly, it has a lot to answer for.

The problem is that once the giving of approval has become the driving force behind any project, curiosity tends to take second place and may even be driven out. If this happens we could be on the road to making that well-known claim, 'I don't know anything about art, but I know what I like' – a rather shabby defence of ignorance.

It is safe to assume that those studying art history feel drawn to the subject, but this does not mean that they should think that all works of art are beyond criticism. It would therefore be best to see 'appreciation' as a possible spin-off from our studies rather than as a primary goal. If we are to make any substantial progress it will be important to look at works of art that are unfamiliar and that may not immediately attract us. This will prove fascinating to those with natural curiosity, but will be a challenge to the few who would like to protect themselves from all things alien. However, this latter group will find the labour involved increasingly satisfying.

The close association between the words 'art' and 'appreciation' has led to another irksome difficulty – the idea that our study is an 'easy option'. That belief is based on two truisms. The first is that 'appreciation' is about the perception of 'beauty', and the second is that 'beauty is in the eye of the beholder'. Putting these two propositions together we can argue that 'appreciation' is an entirely personal matter and that opinions are 'matters of taste' and therefore beyond questioning. If we follow this tempting line of thought, 'study' becomes little more than committing the details of one's favourite paintings, sculptures and buildings to memory. Mercifully, the history of art makes more subtle demands on us, and these, as suggested above, can best be achieved through thoughtful (and immensely stimulating) study.

Art history is a relatively new area of research, but it has already acquired an enormous literature, much of it written and published in languages other than English. That literature has only become possible because there is some

agreement about the use of a specialist vocabulary and particular methods of approach. As scholarship is as much about the communication of knowledge as it is about its accumulation (indeed, the two are inseparable), it is essential that we familiarize ourselves with some of these usages. They will be touched on in Chapter 4.

Apart from using the right words, there is also the problem of acquiring visual literacy. This develops when a student learns to give a work of art his or her 'free attention'. It involves shedding (so far as that is possible) all preconceptions and 'hidden agendas'. Difficult as this is, there are ways of overcoming our resistance to the visually unfamiliar (and familiar!), and one of these is achieved when we translate our experience into another form of expression. Some people, for instance, will benefit by making a sketch of the object while others will do better if they describe what they experience through the written or spoken word. If you can find a patient listener you may wish to speak your thoughts out loud. It is important to realize that neither your sketch nor your words are in any way a substitute for the work of art. They are simply ways of owning up to your perceptions and/or focusing your attention. In the process you will learn something about your tendency to take a biased view (it would be odd indeed if this didn't show itself in your sketch) and this in itself is a part of the business of coming to terms with your experience. For example, those attempting to sketch the Incarnation Initial from the Book of Kells (see the illustration on p. 80) might discover that their natural interest in the tiny details of mice, moths, etc would prompt their relative enlargement. This would result in the loss of the all-important balance, 'flow' and pictorial unity of the page. The sketch would have served its purpose, however, for the dissatisfaction experienced would have greatly sharpened the student's appreciation of the original. We learn about ourselves as we come to understand the object of our attentions. The insights so gained feed back into our way of experiencing the world of art and a seemingly endless process of refinement is set in motion.

Those who study art history with the express aim of furthering their own creative work may wish to adopt a slightly more targeted approach. Their special needs will be dealt with in the next chapter.

Guidelines

- The idea of 'art appreciation' can be a distraction!

- Curiosity is an essential quality in an art historian

- Art history has its own language and methods, which need to be learned

- You will need to work at developing visual literacy and overcoming preconceptions

2 The History of Art as a Spur to Creativity

There is something courageous about the art student who sets out to 'go it alone'. He or she may claim that it is wrong to compromise a personal vision by mixing it with that of others, especially with that of the long dead. How will we 'do our own thing' or break into a bright new future if we keep looking over our shoulders at Raphael or even Picasso? The 'Futurist Manifesto' of 1909 went further still: 'On then, Good Incendiaries! Fire the libraries! ... Turn the floods into museums! Let the famous pictures float! ... We cast our Challenge to the Stars!'

One problem with this brave notion is that it assumes that we were born into a cultural vacuum. In fact, we are in an artistic environment from the moment we first draw breath. Some go further and even say that we bring our tastes and predispositions with us. Others believe that this inheritance comes not just from our immediate forebears, but also, and much more importantly, from the host of distant ancestors that we refer to as our 'race'.

Thus, even if it were desirable to escape from the past, it is almost certainly an impossibility. What *is* possible is that we can play a part in shaping the future. This we will be better equipped to do if we 'own up to' and even embrace our rich inheritance.

No matter how revolutionary, there is scarcely an artist, architect or designer who has wilfully closed his or her eyes to the work of others. A very few (amongst them some of the Futurists) have claimed to do just that, but with hindsight it is clear that even these have been more influenced by their contemporaries and predecessors than they admitted.

Some Exemplars

Perhaps the strangest thing is that it is precisely the more adventurous among creative artists and designers who have benefited most from the study of the art of other times and places. The greater their reputation, the further they seem to have looked. A few examples will suffice to make the point.

James Stirling, Richard Rogers and Norman Foster have between them been responsible for some of the most revolutionary Postmodern buildings in Great Britain and across the world. Soon after Stirling completed his architectural training, he became involved in teaching first Rogers and then Foster. Stirling had

studied at Liverpool University School of Architecture, where, he says: 'We oscillated backwards and forwards, between the antique and the just arrived "Modern Movement".' He recalls his work there on the Classical Orders and also his fascination with Liverpool's nineteenth-century warehouses and office buildings. Even while involved on his highly praised Engineering Building for the University of Leicester he claimed that Mackintosh (see p. 152) and Voysey (1857–1941) represented for him the summit of achievement in British twentieth-century building. Anyone who has heard Rogers speak will recall that he too is deeply versed in the history of the subject and, as might be expected from one born in Florence, he has drawn much of his inspiration from Italian medieval and Renaissance civic building. Foster, whose Hongkong and Shanghai Banking Corporation building is discussed on pp. 46–48, is a man capable of spanning and bringing together not only the centuries, but also different cultures.

Modern painting teems with examples. Pablo Picasso (1881–1973) could be taken as a pivotal point around which to write a history of twentieth-century painting. His powers of invention were with him to the last, yet he was shameless in his passion for scavenging from the past. Apart from absorbing and reshaping virtually every ancient and modern style in European painting, he drew together the art of Central Africa, Gothic Spain, Greece and much else besides.

Few sculptors can have been so concerned with the art of the past and present as Henry Moore (see p. 157). Perhaps his first major creative breakthrough came on a visit to Paris when he saw a Mayan 'chacmool' like that shown on p. 158. He had already discovered, partly as a result of reading Roger Fry's *Vision and Design* (1920), a great interest in African, Sumerian and Egyptian sculpture. Again, when he won the RCA travelling scholarship he spent a lot of time in Florence, paying almost daily visits to the chapel of Sta Maria del Carmine. There he made copies of the work of the fifteenth-century artist Masaccio (see p. 101). It was, after all, the place where, according to Giorgio Vasari: 'All the most celebrated sculptors since Masaccio's day [had] become excellent and illustrious by studying their art.' Here Moore was following in the footsteps of Michelangelo.

The Bauhaus was the leading and most revolutionary school for designers in the third decade of this century. The shock waves that it caused can still be felt in

all aspects of industrial and product design. However, its founder, Walter Gropius (1883–1969), believed that the revolution in design that he sought would be best accomplished by bringing the arts and crafts together. To this end he appointed eight distinguished artists as teachers or *Formmeistern*, the object being to expose his designers to the widest possible range of stimuli. Amongst these artists was Wassily Kandinsky (1866–1944), whose earliest enthusiasm had been for the Russian folk art that he studied while conducting an ethnological survey in the province of Vologda. His book *On the Spiritual in Art* (1912) reveals wide artistic sympathies, stretching from the mosaics of Byzantium to medieval German masters. But his interests, like those of most of his fellow teachers, went far beyond the confines of pictorial art, extending into music, literature and metaphysical speculation.

Having conducted a mini-survey into the background of a handful of architects, painters, sculptors and designers, we might be tempted to draw an analogy between artistic creativity and the theory of natural selection. If, as is claimed, the strongest offspring tend to be the product of disparate parents, might it be that all truly vital art draws on the most divergent influences?

Now that the 'I can go it alone' school of thought has been brought into question, we must consider how best to approach art history in the context of a creative discipline. Of course, what was said in Chapter 1 about the value of curiosity, objectivity and a methodical approach still applies, but creative personalities may wish to proceed somewhat differently.

Practical Steps

Having taught art and design as practical subjects at secondary and tertiary level for many years, I am aware of the difficulty of offering advice here. This is mainly because of the wide variety of approaches quite legitimately adopted by art teachers and also because the 'level' of attainment really is important here. The following comments do no more than outline three broad strategies.

There are few more dispiriting sights than a student staring at a blank drawing board or canvas or at a virgin lump of clay. One cure for this condition is effective if unsophisticated. It might be called (somewhat colourfully) the 'kick-start method'.

For this, a student chooses to adopt the style of an artist or school. For example, a student painter may wish to 'become a Fauve', an ambition born perhaps of an interest in Derain, Dufy, Henri Manguin (see p. 154), Marquet, the early Matisse or Vlaminck. Suitable works will then be studied and an attempt made to emulate them – something much more easily said than done. All of this is fairly sure to set up creative tensions which could lead almost anywhere. A little background reading will show why that most positive, original and 'unexpected' of all art movements – Fauvism – burst upon the world and why its members rapidly moved on. The first objective behind this confessedly crude strategy is simply to ensure that the student does something. However, the Fauve experience might help to 'prime the pump' and a student will, it is hoped, come to draw on reserves of his or her own, offering insights which will involve some genuine, personal and contemporary vision.

Another approach applicable to the student of the graphic or plastic arts is also rather pragmatic, but more challenging. It rests on the belief that in each succeeding generation the artist's main task is to recognize and in some way renew the worn-out schemata (conventions used in representation) bequeathed to us by the past. Thus, for the student whose eyes are fixed on his or her work in the life class, it may be the drawings of Schiele, Sickert (see p. 155), Degas or Ingres that will command attention. This is because if we are to understand our own schemata it will be helpful to see them in the context of those of others.

It is not enough just to look at those masters' drawings; it is more a matter of 'taking on board' what one sees (which might involve the time-honoured approach of copying) and allowing oneself to be challenged by the experience. To realize just how difficult it is to see the world afresh one has only to dip into Ernst Gombrich's *Art and Illusion* (1960). There the author shows many examples of the work of skilled artists who were determined to 'get it right', but who, in the minds of their successors, clearly didn't. You will also come to understand that in our apparently endless pursuit of objectivity there simply is no 'right way'. It seems that all the joy is to be found in the travelling and that 'arrival', though passionately sought, must remain forever out of reach. Further, you may feel that the popular belief in 'progress' in the arts should be viewed with some suspicion. The fact that

Rembrandt (see p. 126) was working 170 years after Leonardo (see p. 106) does not mean that the former 'drew better' than the latter. It is rather that each of these masters brought different sets of predispositions, insights and schemata to his work. These differences are of great interest to the art historian and constitute a profound challenge to the creative artist.

This same passionate search for a new and 'objective' understanding of the world is every bit as important for the student of architecture or design as it is for the painter or sculptor. He or she will continually seek to go back to first principles, and in doing so will want to see how that age-old quest has been tackled by successive generations of builders. Above all, he or she will learn that the famous dictum usually attributed to Le Corbusier, 'a house is a machine for living in', leaves one very important word – living – crying out for definition. For Vanbrugh and Hawksmoor, Castle Howard (see p. 129) was certainly designed for living in – but that kind of living may be thought considerably more gracious and (if we forget Canary Wharf) more indulgent than anything a twentieth-century architect would dare to dream of.

The two approaches mentioned so far will seem quite inadequate to many students and teachers, particularly those who sympathize with the theorists who either shaped or responded to the birth of the 'Modern Movement'. Here I am thinking of those who believe that there is a mysterious 'will to form' somewhere in our nature, something that Wassily Kandinsky called 'inner necessity'. According to this view the artist/designer is seen as a kind of 'sounding board' picking up and reacting to resonances, some from the deepest levels of the collective psyche. These are contentious matters, partly because many (particularly those in authority) are wary of talk of the 'deepest psyche', preferring to see that unseen and uncharted territory, if it exists at all, as ephemeral and unteachable.

Some believe that talk of the psyche leaves the door wide open to the egotist and the charlatan. However, while not necessarily committed to any transcendental views, many teachers (in line with Sir Herbert Read, especially in his magisterial *Education through Art*, published in 1943) know that there is something profound and mysterious about the practice of art and design. Students of this persuasion will do well to be guided by intuition in their historical research. They will seek the

widest exposure to the arts (and to every other relevant experience), waiting for and half expecting things to 'click'. This approach is not to be confused with that bane of every art teacher, the student who 'waits for inspiration', of whom we caught a brief glimpse at the beginning of this section. Rather, our intuitive student is anything but passive in his or her searching and the spin-off from a personal discovery will often be positively dynamic. In scanning and searching, such students will become aware of 'happy accidents', one piece of information seeming to fit quite fortuitously with another. This is serendipity; it is also a valuable stage in the pursuit of wholeness. Others, following the teachings of Carl Jung, think of this as the path to 'individuation', the process of realizing personal spiritual wholeness in keeping with universal laws represented in myths and archetypes.

For these, as for the more pragmatic 'searchers', it will be vital to be aware of 'What's On'. You will try to see all that you can of local and national exhibitions and also to view anything on TV that may be relevant to your interests. To ensure that nothing is overlooked it will be necessary to keep an eye on the press or, better still, to check the listings in specialist art, architecture and design magazines, which you should be able to find in your school, college or municipal library. You will also want to leaf through these magazines and any well-illustrated books. Of course, you should read if you want to, but looking, questioning, experiencing and thinking are the really important things.

In order to ensure that your experiences do not 'go in one eye and out of the other', it will of course be vital to sharpen your focus by the regular use of a sketchbook or notebook. These items are traditionally misused, as, often forming part of a student's course work, they are in many cases rather cosmetic. The really essential thing about them is that they should be as intimate and unplanned as a personal diary. They will record your day-to-day discoveries in words and sketches and they will probably contain postcards, photographs and photocopies. You may also want to use them to keep a record of useful quotations that you have found in books and articles.

We have discussed three ways of relating art history to practical work. These are not, however, offered as rival approaches; they could even prove mutually supportive.

Guidelines

- Innovators are always at odds with traditionalists, but few artists and designers turn their backs on art history

- We cannot escape our cultural conditioning – the wise learn to embrace their past

- The most distinguished artists seem to draw on the most divergent sources of inspiration, from the present *and* the past

- Trying to look at the world through the eyes of others offers exciting creative possibilities

- The visible world can only be represented with the aid of stylistic conventions, which have to be acknowledged before they can be modified or shaken off

- Art can be practised as a spiritual or healing activity

- Make the most of your sketchbook/notebook

3 The History of Art in its Own Right

Selecting a Period (or Periods) for Study

Most examining boards, institutes and colleges in the United Kingdom offer a variety of options; something of this breadth can be seen in Appendices I and III. However, if you are working with others and following a specific syllabus, your choice of study area(s) will probably be limited.

Other restricting factors will be your tutor's particular expertise and the pressures you experience from your peers. For the sake of clarity we will assume in what follows that none of these strictures applies to you, either because you work alone or because you have the necessary skills to persuade your teachers and classmates to follow your lead.

Many teachers and examiners are aware that the modern period, say from 1850 to the present, is by far the most popular with students. More specifically, most interest is concentrated on the painting of the last third of the nineteenth century. It is not altogether clear why this is, but some might think that it is because much of it seems so accessible – both in terms of the number and distribution of original works and also with regard to its nearness in time. It might also be that the subject matter treated by some of these painters appears, even a century later, still comfortably familiar.

The background to some of this material will be touched on in Chapter 8 and this might raise some questions about its apparent familiarity. For now, it should simply be pointed out that many examiners (no matter how hard-working and kindly disposed) wilt under the weight of thousands of written papers and dissertations that focus on those thirty overworked, though fascinating, years.

As mentioned in the last chapter, the most innovative artists of the modern period drew on the more or less distant past for their inspiration. If these men and women were eager to go to the roots of creative expression, why do students insist on attending exclusively to the undoubtedly exciting, but essentially peripheral, branches? Furthermore, using an analogy from psychology, if 'the child is father to the man', why do we not look to the earlier periods of art history to understand better the close and sometimes highly contentious present? Incidentally, isn't it rather odd that candidates will write forthrightly on, for example, 'The Gothic Revival' without knowing anything at all about what was allegedly 'revived'? If you

are required to specialize in more than one area, perhaps it would be a good idea to choose one early or non-Western style as a complement to a 'modern option'. A few A-Level examination boards do in fact make such a selection mandatory.

It is a pity that so few opt for the non-European/modern American work. As the Western world becomes increasingly multicultural it might be expected that we would wish to understand better the cultural origins of the many immigrants (some already long settled) who now enrich the English-speaking world. If there is to be a change it will probably stem from teachers, and it is to be hoped that this daring turnabout will not be too long delayed.

Other factors determining your choice will be the availability of 'primary sources' in your locality. Those who live in or near a major city may find it fairly easy to come face to face with works of art, architecture and design and will be guided by such opportunities. However, there is a wealth of literature at your disposal, much of which can be accessed through school, college or municipal libraries. More will be said on the important matter of books in Chapter 9.

Some centres and candidates place a great deal of emphasis on the value of field trips, sometimes to quite exotic places. These are fine (especially where money is no object!), but they are no substitute for systematic study from books or for work in the classroom or lecture theatre. It is usually there alone that the contextual importance of the works can be properly discussed and understood. The undoubted joy of travel and of encountering works of art and architecture at first hand is increased many fold when one has already come to understand something of the background material. Leaving your study until after your visit is not nearly as much fun and it is often quite depressing to realize that you simply failed to notice so many important things. You may object that books and lectures provide you with prejudice or a 'mental set' that will come between you and works of art and architecture. However, as hinted in Chapter 1, none of us approaches anything, least of all a work of art, with an unprejudiced mind. The history of art is about modifying those preset attitudes in the light of the best scholarship available.

These days many galleries and museums go to a lot of trouble to meet the needs of students, especially in London. You will find details of some of these services set out in Appendix IV. Whether your make use of these facilities or not,

you should realize the importance of setting fairly firm limits to your own first-hand study of original works of art. There are few more distressing conditions than 'aesthetic indigestion'!

Well over half of the present book is given over to looking at a wide variety of works of art in relation to their historical background. You may find that working through Chapter 8 will help you to make a wise choice concerning the kind of art that you wish to study.

Guidelines

- **Don't choose a study area simply because it seems more accessible than others**

- **It can be a great disadvantage to limit yourself to the last decades of the nineteenth century**

- **Extending your horizons is both valuable and exciting**

- **Make the most of visits and field trips by preparing for them properly before you go!**

4 The Language of Criticism

We are less concerned here with the many technical words found in a dictionary of art terms than with fundamental approaches to talking about art and architecture.

The Work of Art Seen as a 'Thing' in its Own Right

We have all met people whose first response to a work of art is to tell you whether or not they like it. If they do not, they may say in what way it is inadequate. This, in modern West Coast parlance, amounts to 'hanging a trip' on the work – they talk about their expectations rather than the thing itself. The tendency is commonly found in association with that seemingly inoffensive word 'too'. Thus, if we look at the illustration on p. 85, some might say that the angel's right arm is *too* long when compared to the size of his thorax. Such an observation begs a number of questions. Not only does it suggest that the speaker has some knowledge of the anatomy of angels, it also implies that he or she knows what the artist was trying to do and perhaps what he was and was not capable of achieving. If we look again we will see that the angel is conceived as a dreadful apparition, and the length of his extended arm is in keeping with the awesome words of instruction: 'Fear not ... and this shall be a sign unto you.' The arm 'proceeds forth' like the words. The picture deals squarely with the biblical events and the emotions at the heart of a story – one seen by the artist and his patrons as being at the crossroads of human history. A work of art or architecture is, in the strictest sense, not *too* anything. It is itself, and we should begin with this uppermost in our minds. *Too* many people are *too* prepared simply to find fault. Taxed with this 'crime', they may ask with good reason: 'What is it then that professional critics do?'

The Role of the Critic

'Every man ought to be a judge of pictures, and every man is so who has not been connoisseured out of his senses.'
 William Blake, 1806.

'Genuine works of art carry their own aesthetic theory implicit within them and suggest the standards according to which they are to be judged.'
 Johann Wolfgang von Goethe, 1808.

In an ideal world professional critics would act as mediators and interpreters. On the one hand they would seek to understand and encourage artists, architects and designers, while on the other they would inform and educate potential 'consumers'. There would be no call for snap judgments, intemperate comments or attempts at character assassination. However, we do not live in an ideal world and incompetence and charlatanism are found among critics as well as among artists. For whatever reason, critics (both professional and amateur) *do* maul things and people that they don't like. We have only to recall Prince Charles's reference to a proposed extension to the National Gallery as 'a monstrous carbuncle on the face of a much-loved and elegant friend'. Indeed, some of the most renowned critics (John Ruskin comes to mind) have been among the most witheringly negative in their approach to works that they did not like. Why, then, shouldn't humbler critics, such as students and ordinary art-lovers, use the word 'too' whenever they like? The answer is simply that measuring the quality of a work of art against a fixed or preconceived standard is almost always unhelpful – whoever does it.

For most of us, a little humility and reticence is called for. It should be a relief to know that we don't have to have a definitive opinion about every work of art that we come across. It we 'rush to judgment' we all too easily close the doors of perception. John Ruskin wrote of a painting by Whistler: 'I have seen, and heard, much of cockney impudence before now; but never expected to hear a coxcomb ask two hundred guineas for flinging a pot of paint in the public's face.' Stirring stuff! But the Court of Exchequer later found Ruskin guilty of defamation. Worse still, history seems to have found that most perceptive, knowledgeable and indefatigable of critics guilty (in this instance) of bigotry. It is much better to argue your case than to jump to conclusions.

The Use and Misuse of Labels

Art historians have invented or accepted labels and categories that enable them to write about specific artists and styles in rather general terms. Thus, they write of 'The Perpendicular', 'The Rococo', 'The Romantics' or 'The Post-Impressionists', leading the unwary to assume that these labels stand for some kind of objective reality. This misunderstanding is seen when we come across some such question

as 'Who do you consider the most Impressionist, Monet, Renoir or Sisley?' The problem here is that the questioner implies that there is some style of painting called 'Impressionist' that exists independently of the way painters such as Monet, Renoir and Sisley painted.

This kind of misuse is overcome when we know something of a label's history. You should know, for example, that it was Roger Fry who coined the term 'Post-Impressionism', simply because it seemed to embrace the fairly disparate styles of those who were dissatisfied with what was then termed 'Impressionism'. It is therefore unhelpful to say that 'Cézanne painted in the Post-Impressionist style'; he didn't – there was no such particular style. Again, it is not very useful to get into a heated argument about just when the 'Decorated Style' began. Some historians have sensed a marked increase in decorative carving in English Gothic dating from, say, 1340, but Thomas Rickman, the architect who coined the term 'Decorated', was referring generally to work associated with the period 1307 to 1377. The Decorated Style, in common with all other styles, is not an objective reality; it is a term used to describe a more or less agreed but essentially subjective assessment.

Labels with More than One Meaning

The word 'Impressionist' is a stylistic term that was first suggested by a journalist as a derisive label following an exhibition in 1874. Since then, it has been used to cover a diverse movement that originated in France in the 1860s and persisted at least until the death of Monet in 1926. However, so great is the difference between the earlier and later works of that master (compare, for example, pp. 145 and 150) that we may ask if the blanket term 'Impressionist' has not come to disguise as much as it defines. The label 'Impressionism' has been stretched further still. Thus it is sometimes used loosely to refer to fuzzy or imprecise painting or even to the lively clay modelling of, say, Rodin. Hence, we also read of Titian's late work showing 'the Impressionism of old age' or even find the Impressionist style associated with such late Roman paintings as that on p. 65.

When the word Realism is spelt with a capital 'R' it usually refers to a fairly specific movement in painting that started in France in the mid-nineteenth century.

When spelt with a small 'r' it may mean anything or nothing. Despite all that philosophers and psychologists have shown us, many people still believe that there is 'something out there' that we can all agree about – something that we can comfortingly call 'reality'. Artists who address themselves to this 'reality' are sometimes referred to as realists or as working in a naturalistic manner. In a desperate attempt to nail this 'reality' once and for all, one is sometimes driven to use the term 'photographic'. But here we may be forgetting that we can take different photos of the same scene (with varying exposure times, depths of focus, etc), none of which has any more right to be termed 'the truth' than any other! Worse still, we may overlook the fact that what one person sees in a given photograph may be substantially different from what is seen by another. A further way of trying to pin down 'realistic' art is to use the difficult word 'verisimilitude', which at least has the distinction of referring to an image that *seems* true to life.

The term 'abstract' has also been used to describe different styles. It sometimes designates painting or sculpture that simplifies natural appearances. At other times it indicates an artistic 'construction' based on non-representational 'basic forms'. This latter definition creates many difficulties, since it begs the question as to where these 'basic forms' originated. Can there really be ideal forms that pre-exist actual ones, as Plato believed? Then, of course, there is the other use of the word abstract as a definition of a work of art that seems unintelligible to the speaker!

We have looked at the possible misuse of eight common terms. However, the list could be extended considerably and might well include the words 'Byzantine', 'Classical', 'Expressionist', 'Futuristic', 'Gothic', 'Mannerist', 'Picturesque', 'Primitive' and 'Romantic', all of which are often used too loosely.

The Use of English

Those who read art history are sometimes either put off or mesmerized by the 'opaque' language used by a few writers. This genre in its most severe form is known as 'art speak' and is sometimes unwittingly imitated by misguided students. The following is a fair example and comes from a dissertation on 'Pop Art and Consumerism':

Therefore, the result of my intrigue and overall fascination with the 'consumer image' within an artistic style, such as Pop, is the portrayal of basic and simplistic objects in scenes, that were in later years, seen and recognised by the public as the works of the 1960's and 1970's.

The duplicity of the soup tin only serves to increase its importance in my view. Why should Warhol have any other reason to repeat himself?

There is just enough here to suggest that the candidate was trying to write in the kind of 'sophisticated' style that some associate with artistic discourse. The candidate's misuse of the word 'intrigue' suggests that he was in some way being 'underhanded' or sneaky. He presumably meant to say that he 'was intrigued' by Warhol and Pop Art, but then that would double up with the phrase 'overall fascination'. Why was it necessary to use the words 'within an artistic style' when this was the subject of the piece? Did the candidate use the word 'simplistic' because it is longer and sounds more erudite than the correct word 'simple'? Further, can the soup tin have shown any 'duplicity' (deceitfulness), and in what sense, dare one ask, did Warhol 'repeat himself'?

Inflated language aside, student vocabularies are often restricted when it comes to expressing approbation. The words 'brilliant', 'stunning', 'fabulous' and 'fantastic' are frequently used but have become so debased in common speech that they have lost their meaning. However, the short passage that ends this chapter is of a different order. It constitutes six per cent of an answer to an A-Level question and was therefore written in about seven minutes. The answer was about the versatility of Donatello and, like the rest of the candidate's paper, deserved an excellent grade:

However, for emotional content, the 'Mary Magdalene' gets the prize. It is still shocking now – then it must have been outrageous. Donatello was an old man by the time he created this masterpiece; and in it we can read his own fear and acceptance of age. Her extreme haggard state is handled with quiet sympathy – her hair, once beautiful, now thick and knotted, is her only dress. Her bones are visible in face, hands, chest and legs, giving an air of

fragility, her eyes are sunken and some teeth missing. Yet she stares up to Heaven as though she can see her Master, and is patiently waiting for death. Donatello, like Michelangelo, was a master at portraying emotional power in his subjects, with a combination of technical expertise, an amazing imagination and extreme versatility.

Guidelines

- **It is important to let a work of art speak for itself**

- **Don't be too free with the word 'too'!**

- **Becoming a good critic may mean not making absolute judgments about works of art**

- **Stylistic labels can be very misleading and should be used with caution**

- **Avoid using inflated and pretentious language; simpler language used accurately is often much more effective**

5 Dissertations, Essays and Special Studies

Many colleges of art, polytechnics, adult education centres and A-Level boards require students to submit sizeable pieces of written work as at least part of their assessment programme. An account of these requirements is given at the end of this book in Appendices I and II.

When a dissertation forms a mandatory part of an examination, it often accounts for some thirty per cent of the total marks. Here the motivated student can improve his or her overall performance, sometimes by as much as two grades. This might be important to those candidates who feel that they rarely do themselves credit under conventional examination conditions.

Some colleges and adult education centres will ask their students to write essays or 'extended essays' on a given subject. This type of assignment will be considered separately at the end of this chapter. However, as there is some overlap between 'free-choice' and 'given-subject' essays, all students should find food for thought in what follows.

The Boundaries of Free Choice

Students are usually asked to choose their topics in consultation with their tutor. In practice this means that, should the idea seem unsatisfactory, the student will be asked to think again. However, the choice of subject is a test of creative thinking and cannot be done for the candidate. Good dissertations spring from questioning habits of mind and are often to be found in quite unlikely places. Some examining authorities insist on approving the topic before work commences and such approval is usually given twelve months before the date of the examination. The following advice should be applicable, whether or not 'prior approval' is an issue.

Your choice will depend on the number of words required. Some schools of art specify studies as long as 10,000 words while A-Level boards tend to favour something between 2,000 and 6,000.

Many colleges and examining boards give candidates the widest possible choice. Usually any subject that comes under the broad umbrella of 'art, architecture and design' is suitable. The time dimension will extend from prehistory to the hypothetical future. All aspects of 'design' are normally included – from the ephemeral vagaries of fashion to the most technical side of, say, civil

engineering. Critical, commercial, iconographic, philosophical, religious, scientific, sociological and technological aspects of art are relevant areas to consider. 'Architecture' may be understood to involve all buildings, not just those designed by 'architects'.

Defining the Subject and Wording the Title

These studies are intended to be pieces of personal research and as such the titles are perhaps best framed as questions. One such title remains fresh in this writer's memory: 'Fournier Street, Spitalfields. A Case Study in Conservation: Is it Viable?' Here a Londoner chose a topic for an A-Level dissertation that involved investigating (through consultation with planners, builders and residents) what the options were for a once elegant street, then in partial decay. The work achieved a well-earned 'A' grade and would have been very acceptable at first degree level.

The Question of Competence

In your choice of topic you should steer clear of 'big subjects'. It is hardly likely, for example, that you could bring much personal insight to an essay entitled 'The Life and Works of Leonardo da Vinci'. This is not to say that your perceptions of that master's work are not valuable and distinctively yours. The problem is that, while there is no doubt much more to be discovered about the great polymath, it is very unlikely to be discovered by someone with relatively little experience or few resources. You could very easily end up writing a paraphrase of some tiny part of the existing literature – and paraphrases are not acceptable. Above all, you should avoid a 'do-it-yourself' psychoanalysis of an artist. These matters are best left to the experts, who will usually show the greatest caution – as did Sigmund Freud in his work on Leonardo – before making the slightest claim to understand or 'explain' an artist or his work. So far as Leonardo is concerned, it *might* be another matter if you chose to write on some narrowly focused aspect of his work, such as his use of atmospheric perspective in three or four paintings.

A 'personal study' is regarded as an original study. Unfortunately, originality is difficult to define and harder still to achieve. King Solomon seems to have summed the matter up when he declared that 'There is no new thing under the sun';

certainly a study of the titles available in the National Art Library would tend to support his claim where the history of art is concerned. Nevertheless, thousands of students do come up with 'original' ideas every year, and the only evidence that the stream has dried up comes from those who settle for some well-worn subject. To make the choice look new students have sometimes invented ingenious titles. One read as follows: 'A Study of the Relationship of the Factory to the Work of Andy Warhol. Working Title: Was the Factory a Real Influence on Warhol's Work, or Merely a Front for his Way of Life and Artistic Aspirations?' Not surprisingly, the actual dissertation was another 'Life and Works' of the artist – something that has been done many times before, often at second, third or fourth hand. Had the student actually been involved in the Factory (or known somebody who was) the choice might have proved more suitable.

In a desperate effort to find something 'new' you might be tempted to go for an artist, designer or architect that very few people have heard of. Friends, close relatives and teachers have all been tried. Unfortunately, no matter how well-intentioned you might be, your closeness to the subject will invariably distort your judgment. Thus, one student failed to be wholly convincing when she compared her favourite aunt first to the Fauves – 'she leaned towards them in a subtle yet poignant manner' – and then to Michelangelo:

> *So, just as Michelangelo had turned towards the church for commissions partly because of their substantial funds, she likewise turned towards the successful businessmen of the 1980s who were, understandably, keen to show their new status.*

Ideally, the topic should, unlike the above, be associated with some easily accessible contextual material such as reviews, articles and catalogues – items that should be included, specifically referred to or quoted in the finished work. Otherwise an examiner will have little on which to make his or her assessment of the student's *own* role in the study. All the same, in another respect the instincts of the student quoted above were sound: the subject matter *should* be one to which you can readily relate.

Some students are fortunate in being extremely close to their subjects, actually living in the stately homes that they describe so knowledgeably. One student chose to write about her own home, which had been designed and built by her father, a well-known practising architect. Why should she not choose to discuss that house? She did, and did it very well. However, candidates ought to realize that the examiner's task is to assess the student's contribution to the study; no one is really disadvantaged. Subjects can still be found on your own doorstep – even if your father didn't have a hand in laying it!

Research Methods

While a few good dissertations are researched at home, school or college, most depend on what might be called 'leg work'. This is because, for most students, it is important to get as close to source material as possible. Thus, visits to windmills, Martello towers and fast food restaurants have all been starting points for in-depth studies. After reading some way into their subjects, students have written to owners, caretakers or managers and have set out on journeys of discovery. They have returned with photographs, drawings and notes recording what they experienced. The final work has then turned out to be a unique compilation based on various types of knowledge, some primary and some secondary.

A few students secure interviews with well-known architects, critics, curators, designers, illustrators, painters, etc. Here candidates should remember the privilege that has been bestowed on them and make sure that they approach their subject with their minds already well informed. You should not insult your quarry by asking him or her about things that you could have learned from published works. You may of course say something in your finished work about how you felt when you came face to face with your subject – scholarship is hardly ever an impersonal matter.

Well-designed questionnaires are useful tools in this age of opinion-seeking. However, if this approach is to have any statistical value, students must always give the number sampled. To claim that 'twenty per cent said that they had never noticed Barbara Hepworth's *Winged Figure*' might simply mean that five passers-by had been inconvenienced in London's Oxford Street.

Illustrations

Almost all dissertations will be illustrated, though in most cases this is not absolutely essential. Here the chief source of pictures will probably be photographs, ideally ones taken by the student. Those students who are involved in a practical art course might seem to be at some advantage when it comes to supporting their work with drawings or photographs. In truth, however, as far as students of art history 'pure' (rather than 'applied') are concerned, the graphic work will usually be assessed only where it advances the student's argument. Its intrinsic artistic quality, though always valued, will in almost all cases play no part in the final grading. When photocopies are used, care should be taken to find a good machine that is sensitive to halftones. Colour photocopies are generally fine, though it is interesting to see that a few students are prepared to 'prove' arguments about colour by making suitable adjustments to the controls! In order to show how widely you have ranged in your research, it is a good plan to list your illustrations, showing not only the present home of the artifact but also the source of your picture.

Presentation

How you divide up your text will depend somewhat on the required length of the essay or dissertation. Some students dispense entirely with Introductions, but where they are supplied they are often very helpful to the examiner, since they serve to anchor the work to the student's own 'reality'. The following makes the point:

> In February 1991 I spent a week in Madrid and Barcelona on a combined art and Spanish study trip. In Barcelona we looked at some of the work of the Spanish architect, Antoni Gaudi. It was the first time I had ever seen any of Gaudi's work. My first and lasting impression was that it was the most exciting and unique architecture I had ever seen. ... The grey stone architecture that I had left behind in London began to fade from my mind, as in contrast Gaudi's vibrant colour, decoration and combination of sculpture and architecture absorbed me.

This writer made no attempt to avoid the first person, and there is absolutely no reason why she should have. Those who insist on the royal 'we' often sound as if they are taking the reader's opinions for granted and, when all trace of 'person' is removed, the text can read like a god-given pronouncement – a sure sign of a poor art historian. It also leads to the kind of guidebook impersonality that is encapsulated in a line from a particularly bland and 'superior' dissertation on a stately home: 'The only painting worth note in this room is Isack van Ostade's Peasants by an Inn.' Can it be that we peasants and mere mortals have no right to an opinion?

All researchers worth their salt show where (and sometimes how) they obtained their material. This may be done through footnotes or by attributions in the main text. It is not enough to leave the reader to find his or her own way through the appended bibliography. It is the inadequate student who attempts to hide sources. By doing so he or she invariably arouses the examiner's suspicions and is in danger of losing both credibility and marks. Plagiarism is essentially deceitful. At what point the crafty weaving of rephrased passages ceases to be plagiarism and becomes intelligent synthesis is a matter of debate, but you may be sure that examiners are equally crafty in detecting this not-too-subtle approach to originality.

Some examining authorities make it clear that tapes and videos would be welcome, either in support of the written text or (in a few cases) as a substitute for this. However, if this option is not given, students should check first before making any such submission.

Where a Conclusion is called for, it should be distinguished from a summary or abstract, the latter being more appropriate at the beginning of your work. In a Conclusion you may wish to draw the threads of your argument together, but the intention should be to come up with a resolution to any problem that you have been considering. It is sometimes helpful to set the opinions of one 'authority' against another and to show why you favour one rather than the other.

The physical presentation of the final work is often a matter of much understandable pride. The text may be typewritten or printed with the aid of a word processor. Alternatively, students will sometimes offer their work in legible

longhand and occasionally in finely penned italic script. The bindings may vary from a loose-leaf folder to one professionally produced in boards and richly tooled leather. Attractive and welcome as these works may be, one thing is quite certain: the expense involved has no effect at all on the marks awarded. Only if the dissertation were on some aspect of bookbinding or calligraphy, and if the student could show that the production was appropriate and entirely his or her own, would the examiner be likely to take the presentation into serious account.

The Sketchbook/Scrapbook Option
As mentioned above, some authorities allow students to submit a large sketchbook or scrapbook (A3 is sometimes specified) instead of a dissertation. These can certainly be fun to produce and they will appeal, as they are meant to do, to the practical artist/designer. He or she, in theory at least, will have all the relevant skills associated with presentation (mounting, gluing, captioning, binding, etc). The work will be more ordered than the notebooks and diaries mentioned in Chapter 2, because the aim is to expound and/or present the material to the examiner. You will have the same range of choice as that available to students producing the 'written' studies discussed above, though in your case the work will be essentially an artistic production – something appealing in its own right. The emphasis on originality might be considered less restrictive here, as the method of presentation could be scope enough for demonstrating a personal approach. You may, for example, wish to give an account of how some basic form or structure (such as the spiral or the mathematical progression known as the Fibonacci series) manifests itself in art and nature. Your material will be grouped and balanced so as to provide maximum impact and there will be a nice relationship between your text and/or captions and pictures. Photographs will perhaps alternate with your own drawings, prints and engravings.

Writing to a Given Subject
Some of these assignments will be set as training exercises and some, like the Open University's TMAs (Tutor-Marked Assignments), will be part of an ongoing assessment programme. The latter will be intended to reassure the student as

much as the tutor, and it may also be a form of training, preparing the student for the demands that lie ahead. Length will vary, but essays of 2,000–3,000 words may be expected. The time allowed for completion will also vary, but three or four weeks is about the average.

Whether the subject is precisely defined or fairly general, the wording should be carefully studied. You may think it impolite to start your essay by questioning the wording of the assignment; however, it is important that you ask yourself what exactly is required. If the set topic involves a term, or terms, whose meaning is open to interpretation, such as 'Classical', 'Conceptual' or 'Baroque', you should be prepared to begin your essay by defining the sense or senses in which you intend to use that term.

It will then be important to gather your material together systematically and in manageable pieces. These may be short texts from set or recommended books, duly isolated with bookmarks of annotated strips of paper. You will have your lesson or lecture notes, also marked up for easy reference. While all this preparation is going on a provisional synopsis should be forming in your mind.

How you proceed with the writing will be determined by your temperament and circumstances. Some will get through at a single sitting in a kind of creative ferment. With all that helpful material around you, you may feel free to strike out alone, drawing principally on your memory, your ability to synthesize fairly disparate material and your natural enthusiasm for the subject, and pausing only to check that you are not misremembering your sources. Others may well want to take days, or even weeks, over their essay, weaving and interweaving the assembled material with bookish zeal.

As described elsewhere in this chapter, it will be essential to acknowledge your sources and to include a working bibliography. The principal difference between these given-subject essays and the free-choice dissertations is the emphasis concerning the type of originality involved. With a given-subject essay the personal contribution to the work is tied firmly to your ability to understand, restructure and express the substance of what is usually fairly well-known material. For the free-choice study the aim is to produce something that is, at least to some degree, new.

Guidelines

- Take care over your choice of essay subject and title – it's a critical part of the task

- Avoid subjects that have been tackled often in the past

- Choose something that interests you personally

- Beware of plagiarism

- Set your work out clearly and systematically

6 Written Papers

Those who study the history of art do so for positive reasons. Students taking more traditional school subjects, by contrast, may be differently motivated, seeing each success as a step on an educational ladder that will eventually lead to some possibly unrelated end. With this difference in mind, it seems unlikely that readers wishing to pursue art history would welcome a narrow examination primer. Nevertheless, something must be said about the techniques involved in addressing questions under examination conditions.

The history of art is one of the subjects that not only allows but encourages students to make their own observations. The 'raw material' of the subject is available to every student. This remains true even when access to that material is largely through slides or reproductions in books. There is no central core of beliefs that is beyond challenge and attentive readers will know that even when writers do agree they often differ as to where they place their emphases. The subject is therefore a 'living' study at all levels and this is its main attraction for many.

Very occasionally one still comes across the belief that history of art papers are designed to test how well candidates can remember sequences of facts, alleged sets of influences and summaries of supposedly acknowledged qualities. Apart from tending to kill the subject stone dead, this approach leads to the business of question-spotting – an understandable but often self-defeating game. Whether practised collectively or individually, it encourages the preparation of stock answers which can be modified and 'slotted in' to fit questions on the day of the examination. In the few centres where this still goes on, it is reflected in the answers submitted. The mismatch between the questions and answers is usually all too clear. Moreover, where a whole centre is involved, the examiners are faced with reading a set of virtually identical essays, sometimes illustrated with the same homely anecdotes!

It must be emphasized that art history examinations are carefully designed to discover how stimulating you have found your course. Questions are set to cover as much of the syllabus as possible and to find out whether candidates can handle art-historical material in a way that shows empathy and understanding. The aim is to assess the student's ability to think creatively and to express thoughts and feelings clearly and methodically. To put it another way, the examiner wants to know

which candidates have the instincts of art historians. This is the test that should be applied at every level from age sixteen to sixty and in whatever kind of school, college or institution you happen to be taught.

If you have enjoyed your course, covered the syllabus and done some conscientious revision you have no need to fear. Nervousness is another matter. That probably means that you want to give of your best, and there is no better prognosis of success than that.

You will need to answer the required number of questions, and that involves timing your answers. If you find that you are overrunning, try compressing your closing paragraphs into as many sentences. Missing out a question or attempting to put the last answer in note form is usually a recipe for disappointment.

I have argued against an undue reliance on memory. However, certain important quotations, accurately remembered or suitably paraphrased, can act as reference points on which you may want to hinge answers. And while there is no reason to supply the dates of every artist, architect or designer that you mention, there are certainly some pivotal dates that you will need to keep in mind. Also, there is no reason why you should not use mnemonics, or any other trick that helps, provided you do not see the examination as *simply* a test of memory.

Some art history examinations include a compulsory general paper. This is designed to assess the breadth of a candidate's general knowledge of art and architecture, the role of art in human affairs and sometimes in the candidate's own locality. These papers may include a compulsory picture question and at least one board asks candidates to attempt to attribute the work. Apart from honing one's writing skills and reading widely there is little that one can do by way of preparation.

The array of lucky charms and mascots arranged on examination desktops suggests that the belief in sympathetic magic, thought effective 25,000 years ago (see p. 55), is by no means dead. Nonetheless, there is a precaution that you will have taken earlier, ideally years earlier, which is summed up in the adapted adage, 'Fortune favours the well-prepared mind.'

Guidelines

- Art history students shouldn't need exam primers or crammers

- Don't just write prepared essays – answer the questions properly

- Pace yourself in the exam – you must finish the paper

- Be selective about what you learn – decide what the really important facts are before you start

- Read widely and develop good study habits at the beginning of your course

7 Picture Questions

These are designed to elicit a first-hand response and are employed at all levels. Their use at A-Level is shown in Appendix II. As with other written questions, they are not primarily tests of memory and so the pictures are almost always accompanied by facts concerning authorship, date, present location, title, class of object, etc. While some questions concern single pictures, others involve pairs. In the latter case the pictures may show two views of the same artifact, sculpture or building, but sometimes these pairs show different works of art and students are asked to compare one with another.

The first example is taken from a paper where the pictures were relevant to an option called 'Revolution and Rococo', and the questions are therefore fairly specialized. They are designed to discover how well candidates can analyse their responses to two pictures. Although students were not expected to spend the same time on each sub-question, the marks awarded for each were equal.

Illustrations: (i) *The Swing* by Jean-Honoré Fragonard (1732–1806);
(ii) *The Swing* by Francisco Goya (1746–1828).

Students were asked:

(a) In what way do the paintings differ in their use of chiaroscuro?

(b) In what ways do they differ in overall linear and geometric composition?

(c) What differences are there in the handling of the medium?

(d) How do the above factors affect the mood and/or 'meaning' of the pictures?

The following is one of many possible answers:

(a) Taking the word chiaroscuro to mean 'the balance of light and shadow in a picture', in the Fragonard the principal subject appears light against dark,

Picture Questions

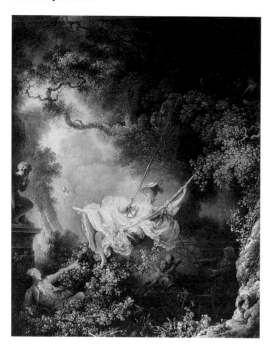

Jean-Honoré Fragonard
The Swing, c. **1767**
Oil on canvas
83 x 66 cm

Francisco Goya
The Swing, **1786–87**
Oil on canvas
169 x 100 cm

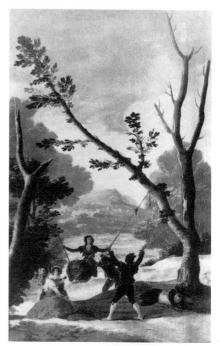

while in the Goya it is dark against light. Fragonard's modulation of tone is gradual, while Goya's variations are rather more sudden and are most noticeable in the difference he makes between the strong contrasts in the foreground and the subtle ones in the distant landscape. However, the word chiaroscuro may also refer to the modelling of forms by slight tonal gradations, in which case this is more obvious in the Fragonard than the Goya.

(b) In the Fragonard the principal figure is placed at the intersection of two near-diagonals – one suggested by the passage of light which runs some of the way from top left to bottom right, the other passing along the raised arm of the admiring Baron and upwards through the arm of his mistress. In the Goya the line of the overhanging branch restricts the principal subject to the lower half. The angle made by the ropes of the swing is echoed elsewhere in the picture, most clearly in the gesture of the male figure who stands with legs astride, but also in the relationship of that figure to the female who is leaning backwards to the left of the swing. The Goya composition is angular, complex and subtle. The Fragonard is by contrast obvious in its overall structure. Within this simple arrangement, there are many typically Rococo C-shaped curves, seen especially in the billowing costume, the Cupid and the all-enveloping foliage.

(c) The handling is not really clear in the photographs, but it may be safely imagined that the Fragonard would show typically fluent use of layers of semi-transparent oil colour. Goya's handling, however, is likely even at this relatively early date to be rather more impassioned and summary.

(d) In the Fragonard the shaft of light emphasizes the direction that will be taken by the swing. The simplicity of the design places the focus on the mistress, drawing attention to the open frivolity of the scene. In the Goya the diminutive size of the puppet-like figures seems to show their childlike vulnerability, especially with respect to the wider world. The fact that the supporting trees are dead or dying underscores the fleetingness of time.

The above is not in any sense a 'right answer'; there is no such thing. References to 'frivolity', 'childlike vulnerability' and 'the fleetingness of time' are clearly subjective comments and are some of the points that would be open to debate. However, in the context of an examination answer there is no need to prefix every opinion with the phrase (strictly speaking, correct and courteous) – 'It seems to me that …'. Prior knowledge of the story behind Fragonard's picture was introduced in the reference to the Baron, his mistress and the Bishop. This was not actually called for, but it was just as easy to name them as to write about 'the figure on the right', etc. Some examinees illustrate compositional points with the aid of sketches, but these should be kept as diagrammatic as possible. Attempts to reproduce pictures should be resisted – especially if you have some special skills in that direction! Such efforts too often obscure the purpose of the exercise and waste a lot of time.

Our second example of a picture question is from an option called 'Art, Architecture and Design, Twentieth Century'.

Illustration: Foster Associates, Hongkong and Shanghai Banking Corporation Headquarters.

(a) Describe the general appearance of the building in not more than 150 words.

(b) Foster says that his design has been 'strongly influenced by sources outside the traditional building industry'. What do you think these may have been?

(c) Some contemporary architects have given primacy to the 'skin' of their buildings, while others have emphasized the 'skeleton'. Where do you think the emphasis is here and whose work would you cite as an example of the opposite approach?

(d) One writer has described the building as a 'strange mixture of reality and techno-romanticism'. What do you understand by this?

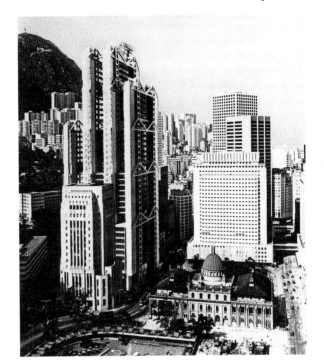

**Foster Associates
Hongkong and Shanghai
Banking Corporation
Headquarters, 1979–84**

The following is one of countless possible answers:

(a) The building towers over its neighbours and consists in the main of three parallel 'slabs' of unequal height suspended from a framework of trusses and tubular steel columns. The latter are grouped in two rows at the east and west ends of the building. The elevation is divided into five horizontal zones by floors of double the normal height. The central section consists of forty-seven floors, the front or northern façade of thirty-five floors, while that to the south only reaches level twenty-eight. Each 'slab' is 'tied' to its neighbour by X-shaped braces and the central slab is pierced by a giant atrium which rises to the level of the first suspension trusses. The ground plan of the building is a conventional rectangle but the various setbacks give a variety of plans at different heights, tapering to the helicopter pad at the summit.

(b) Foster himself spoke of a 'spin-off from aerospace and other advanced industries'. Here he may have been thinking of rocket-launching structures, oils rigs, etc.

(c) The emphasis, in contrast to some of Foster's earlier buildings, is on the skeletal structure. Richard Rogers, on the other hand, now tends to emphasize the 'skin' of his buildings – as can be seen in the Lloyds Building in the City of London.

(d) It seems to combine 'technologies ... from indigenous craft-based units' (Foster) with the creations of science fiction – perhaps like those seen in Stanley Kubrick's '2001 – A Space Odyssey'. It was also seen as virtually an arm and symbol of government in the most substantial of Britain's remaining colonies. The architects were willing to consult a geomancer about the local belief in the importance of the building's orientation.

The description given under (a) could not have been made solely from the photograph, as it involves some knowledge of the related structural principles, specific details about the building's orientation and information about the number of floors. Nevertheless, a description could have been offered, based simply on what could be seen in the photograph rather than what was understood in the light of prior knowledge. In this case the description might, for example, have mentioned a 'ladder-like framework, supporting structures that resemble giant coat hangers, joined shoulder to shoulder'. Heights could have been referred to as 'some forty-seven floors' or 'getting on for fifty floors'. This would have been a resourceful and legitimate approach for a candidate who had not studied this specific building and could have earned him or her substantial credit.

Levels of Understanding

The above example may serve to illustrate how knowledge conditions the way in which we see a work of art, and it will serve to lead us on to slightly more complicated issues that often surface in picture questions. These we will approach by way of a work of sculpture:

Illustration: *The Ecstasy of St Theresa* by Gianlorenzo Bernini (1598–1680). Altar in Sta Maria della Vittoria, Rome.

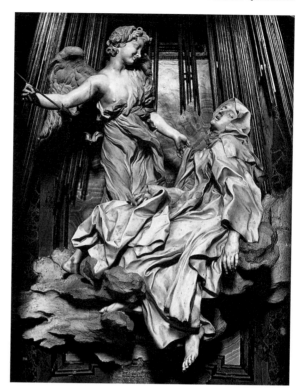

Gianlorenzo Bernini
The Ecstasy of St Theresa,
1645–52
Coloured marble and gilt metal
Lifesize

We will first try to describe the work as it might appear to the relatively 'uneducated eye':

> The work is a three-dimensional representation in stone of two figures, one of whom is upright while the other seems to be falling backwards, her left foot hanging limply beneath the lower margin of her voluminous clothing. The gaze of the standing figure is directed towards the other, who, from her expression, seems to be fainting. The standing figure has wings protruding from her back and carries an arrow in her right hand, as though she were preparing to pierce the recumbent figure with it. Nevertheless the expression on the 'assailant's' face seems anything but aggressive …

As this description might seem too 'matter of fact' we could bring in the kind of background knowledge that involves 'iconography' (the investigation of subject matter). Thus we could add:

> The carving represents a dream or vision said to have been given to a Spanish nun named Theresa. She felt that an angel had pierced her heart with a flaming arrow and that this was a token of God's love for her – causing her pain but great bliss. The story is given added point when one recalls that St Theresa's faith was grounded in the doctrine of the 'atonement', i.e. the idea that suffering (through that of Christ) is redemptive. The theme also brings to mind the sufferings of Christ's mother, of whom it was prophesied: 'Yea, a sword shall pierce through thy own soul also.'

While the knowledge set out in the last paragraph may take us a stage further in 'understanding' the carving, it should not blind us to the reality of our first description, nor should it prevent us from looking further into the work's meaning. This might involve us in the following observations concerning 'iconology' (the interpretation of subject matter):

> In mentioning the atonement and the story of Mary's suffering, the passage above has already ventured into the realms of interpretation. However, we can go further. Bernini was giving expression to the needs of those Catholics who wished to restate what they held to be the primacy of Catholic doctrine. This asserts the abundance of God's grace, more especially in the way it had been channelled through the lives of the saints of His one ordained Church. Catholics also wished to reaffirm the centrality of Rome (where Bernini's works were mostly sited), a city transformed by SS Peter and Paul into a 'diadem', a holy city at the heart of Christendom. All this 'certainty' had to be expressed in obvious contrast to the self-absorption and apparent pessimism that traditional Catholics sensed in the newly emerged Protestantism.

From this we can see that the meaning of the subject is intimately tied to the nature of seventeenth-century Catholicism. We have yet to look at Bernini's 'style'. We might begin as follows:

> The work is arranged so that it admits a relatively restricted view, much as if

we were looking at a tableau. There is a good deal of emphasis on meandering lines (moving as much into as across the forms) and on brightly lit planes. The latter are frequently interrupted by deep and dark hollows. The unruly and florid nature of the forms is wholly in line with the 'Baroque', a stylistic label said to be derived from the Portuguese word 'barroco' meaning 'an irregular pearl'. Everywhere one may sense a lively energy which in another context might seem sensuous or even sensual. Here, however, corporality is conceived in terms of the sinful flesh that was bought back by Christ's sacrificial death on the cross.

At this point one might notice that the iconological considerations have shaded into stylistic ones. The formal devices are so assured that they demand the suspension of disbelief. We might go on to ask whether this dramatic presentation was related to the contemporary emphasis on persuasive oratory, especially as practised by the Jesuits, emissaries of the Pope in Rome and prime movers in that Catholic renewal now known as the Counter-Reformation.

Where Does Iconology End?

The answer to this question depends on one's understanding of the nature of art. There are those who believe that works of art have to be reinterpreted by each successive generation and that their 'ultimate meaning' can therefore never be known. What then are we to make of H.D. Molesworth's claim that 'To the modern observer Bernini's figure of St Theresa, as it were frozen in marble at the climax of a self-induced orgasm, is acutely embarrassing'? Surely such an interpretation depends on a late twentieth-century view of human sexuality and (if we may judge by the literature of the time) is far removed from the thinking and feeling of the society that allowed Bernini to rise to fame. There is, however, another way of putting some distance between oneself and a work from the past. In his lecture series 'Civilization', Sir Kenneth Clark expressed 'certain misgivings' that he felt about Bernini's work. These he said could be summed up by the words 'illusion' and 'exploitation'. Here he seemed to be taking an outsider's view and making a comment about what he saw as the exploitative and deceptive (even deceitful?)

nature of Bernini's work and, by extension, of the society that he served. Clark was, of course, taking an overview of history in the light of his own beliefs about the nature of civilization. For us it will be enough to try to see and understand the past in its own terms, not ours.

Guidelines

- **Exams are not just a test of memory – remember to keep looking**

- **Writing or talking about art requires different kinds of understanding: visual, historical, philosophical, iconographic and many others besides**

- **Try and see the past in its own terms before talking about its value or meaning for us today**

8 Art and Design in Context

In Chapter 1 we examined art as something to be appreciated; here we consider how and to what extent it can be understood in relation to its background. We will look at a number of buildings, paintings, pieces of sculpture and other artifacts to see in what way they may have been conditioned by their times. Economics, politics, philosophy, religion, science, sociology and technology are all considered, but in this short survey it will only be possible to touch on one or two of these in relation to each given work. There will be no attempt to explain works in any final sense. In the last resort all understanding rests on one's psychological make-up; and there will therefore be as many interpretations as there are interpreters. Often the comments offered here are little more than hints that might encourage further reading. Throughout an effort has been made to exclude stylistic assessments and 'value judgments'.

The Greeks believed that the various arts and sciences were inspired by one or more of the nine muses. Artists have also been seen as the recipients of a 'talent', a gift from God; in still more recent times, creativity has been ascribed to deep tensions within the human psyche. While not wishing to undervalue these ideas, the thesis that art is fundamentally isolated from worldly concerns cannot be sustained. There have always been those who like to see art as 'value free' (that is, having nothing to do with what may be broadly termed 'politics'), and it is a view that has been espoused mainly by those who are most interested in the monetary value of art. It has enabled the wealthy to enjoy the hard work of others without feeling too much in their debt. While the patronage of the rich has been immensely important for the arts, artists have all too often simply been patronized.

The nature of the relationship between the arts and their times is much debated. There are those who speak of history as if it had a life of its own and had evolved much like a biological organism. They talk of the Zeitgeist (the spirit of the times) almost as if history were not merely a living thing but also had a soul. The more prosaic simply consider history to be the record of the way certain events and individuals have shaped the past. Somewhere between these extremes is what might be called the 'billiard ball' view of history – the awareness that actions and reactions at any given period are so swift and complex that no single factor can be understood except in the context of its relationship with all the others.

This may be illustrated with reference to a major development in painting at the end of the nineteenth century when many negative effects of the Industrial Revolution continued to be felt, particularly in the towns and cities of Western Europe. Recently torn from their agrarian roots, and often separated from the end-product of their labours through the factory system, many people felt lost or cut adrift. Developments in science and philosophy had weakened belief in the biblical account of history, and the authority of the Church (at that time more than ever divided) was profoundly questioned. Revolutions had come and gone and the hopes they had inspired seemed dashed, compounding a sense of hopelessness and alienation. Some seem to think of those closing decades of the century as if they were capable of emotion and speak of a mysterious 'fin-de-siècle ennui'. If this is a true picture of the emotional climate of those times, one might imagine that individuals who had their own personal reasons for feeling dispirited would be particularly burdened. They might even have become natural 'spokesmen' for their tortured age. In his *Painting and Sculpture in Europe, 1880–1940*, G.H. Hamilton has made such a case for the emergence of James Ensor, Vincent van Gogh (see p. 147), Ferdinand Hodler and Edvard Munch, all artists held to be typical of those closing years. It may then be claimed that they and many other artists were simply 'mirrors' reflecting the mores of a tired and disillusioned society. However, we should be careful of such generalizing views, since a very different description of the context of late nineteenth-century art would be needed to account for the 'Naughty Nineties'. This may also have been the expression of a disillusioned society, but it is obviously a very different response from, say, Van Gogh's.

The 114 works discussed below are arranged in something approaching chronological order. However, it must be confessed that the choice of subjects and their arrangement is frankly centred around the art of Europe and modern America. Thus, although Asiatic and Mesoamerican works are sometimes put in their proper 'time slot', elsewhere they have been placed at the point where they become relevant to the 'West'. It is also regrettable that women artists are under-represented. These are weaknesses, but they do sadly reflect the weighting given to the various traditions in the published syllabuses. The chart in Appendix V shows the approximate dates of most of the works or artists discussed here.

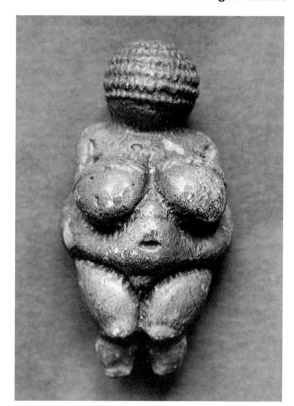

'Venus' of Willendorf
c. **27,000–25,000 BC**
Limestone
Ht 14.7 cm

What little is known about the people who lived before recorded history is largely based upon studies of 'modern Stone Age cultures', notably the San or Bushmen of southern Africa and the Australian aborigines. From this and similar types of research it appears that art once served secret purposes, the chief of which is called 'sympathetic magic'. This is the belief that 'like produces like', an idea still covertly cherished by modern men and women – if psychotherapists are to be believed. In this neatly coiffured 'Venus', we may see the bulging breasts and distended stomach as signs of pregnancy and imagine that the Stone Age craftsman (craftswoman is rarely suggested!), working on the basis that 'like produces like', was trying to ensure the fertility either of his mate, his species or (by extension) his crops. However, many questions remain. Was this figure a 'Venus' in the sense that she represented an ideal of female beauty or was she a distant prototype of the Greek goddess Demeter, a goddess of Mother Earth, perhaps intended for ritual burial like a ripe seed?

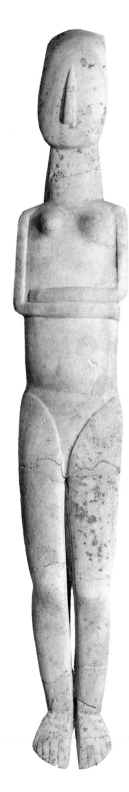

Cycladic female figure from Amorgos
c. **2200–2000 BC**
Marble
Ht 148.5 cm

This is one of many similar carvings once made in the
Cyclades. These islands span the south-western
approaches to the Aegean, and their inhabitants led the
field of creative art in the region. The islands of Paros and
Naxos are particularly rich in a crystalline, translucent white
marble and this, duly cut with Bronze Age saw and drill and
polished with abrasives, is the material basis of the present
figurine. Like most of the associated figures, it is female
and the clear demarcation of the various parts suggests
that the artist was eager to conform to some kind of rule
based on human proportions, but was not slavishly copying
any ideal. Elegant Cycladic 'idols' were sometimes placed in
tombs, even in ones as far away as Crete and the Greek
mainland. Just why these islanders were so obsessed with
ideal proportion and what role the figures played in the rites
of the dead is not clear. It may be that here we have the
beginnings of a cult of perfection, centred on the idea of
human beauty, which was to find its best-known expression
in the art of Periclean Athens.

Wall-painting from the tomb of Menna, Thebes
c. **1415 BC**
Gouache on stucco

After centuries of priestly restriction and a period of foreign invasion, Egypt entered its Eighteenth Dynasty with the promise of rebirth. The New Kingdom extended its control from the Euphrates to the Sudan and, while the old piety and much of the artistic tradition remained, there was now a new delight in worldly pursuits. Colourful paintings, worked in gouache over dry plaster, were favoured above the traditional incised and painted decoration. Most of these murals, like this hunting scene, are found in the tombs of the pharaohs and especially in the vicinity of the once prosperous city of Thebes. It is as though the victories over the Hyksos had given the Egyptians a taste for the opulence and worldliness of their would-be oppressors. Here we have the memory of a garden lined with papyrus reeds and teeming with birds. A family is engaged in catching these beautiful creatures, while at the same time spearing fish. As if the paintings were not sign enough themselves, there are also indications that some artists were now both able and willing to work directly from life. Such evidence is found in lively sketches made on potsherds.

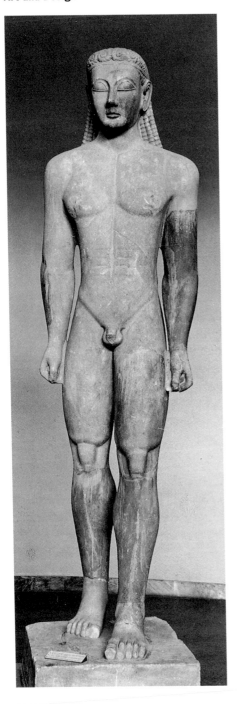

Kouros of Sounion
c. 600 BC
Marble
Ht 305 cm

After the collapse of the Mycenaean Empire, Greece and its neighbours suffered successive invasions and much general lawlessness. When in the ninth century order began to emerge, the Greek-speaking peoples remained divided in city-states. These proud factions were later to come together for athletic events, more especially the four-yearly interstate games or Olympiads, the first of which took place in 776 BC. These states were also linked by their devotion to a pantheon of gods, all personifications of various aspects of nature. So profound was the Greek reverence for these deities that athletes honoured them in victory. Hence this over-lifesize Kouros (Greek for 'young man') represents an athlete in the act of reverential approach, perhaps towards a statue of Poseidon (the figure once stood before a temple dedicated to that god). The somewhat rigid pose, advanced left leg and squared shoulders, owes something to the Egyptian tradition, but the emphasis on the muscular structure and the articulation of the parts is essentially Greek. Greek, too, is the rare combination of religious piety and delight in physical vitality.

Exekias
Black figure amphora, *c*. 550–40 BC
Pottery
Ht 61 cm

The earliest Greek pottery, like so much of that nation's art, is associated with the Cycladic islands. After some intermingling of influences, notably from Assyrian art via Corinth, Athens herself became a major exporter of pottery, producing vessels that could carry up to nine gallons of wine, oil or honey. The 'black figure' ware was painted in glossy black enamel, usually over a lightly glazed reddish clay ground; the decorations are almost all there is left of Greek painting as an art form. It is therefore interesting that, despite at least one painter's claim to illusionistic skills, these pottery images are relatively formalized. The human figures are almost always seen in profile and the expressionless faces have eyes seen front-on. Despite these limitations, the monumental figures are remarkably expressive. Here the two doomed heroes, Achilles and Ajax, pass away the hours during the long Trojan siege playing dice. The V-shape arrangement of the spears seems to concentrate our attention on the game. Pots such as this played a part in disseminating not only Greek products and skills, but also the legends at the heart of their culture.

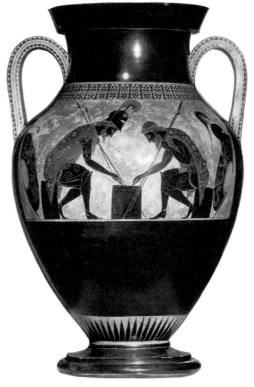

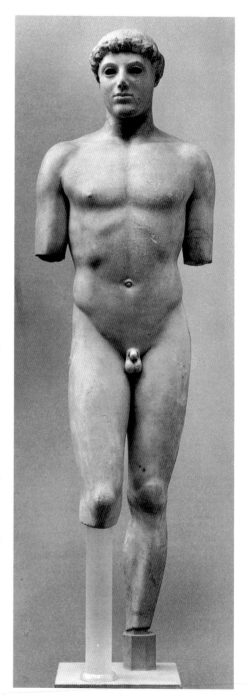

The Kritian Boy
Before 480 BC
Marble
Ht 86 cm

From the start of the Classical period
(*c.* 500 BC) sculptors tried to enhance the
feeling of dynamism latent in such works
as the Kouros discussed on p. 58. As
confidence grew, they found that movement
could be implied by the subtlest means. In
the present figure the weight is on the left
leg, causing the pelvis to tilt very slightly.
This sets off the gentlest of responses
elsewhere in the body. The forward tilt of
the abdomen is countered by a
complementary shift in the angle of the
thorax. The head turns as if it were in some
sense leading the figure – an action that
anatomists recognize as primal in all
human and animal locomotion. The work
was produced at the very moment when the
city-states were beginning to find common
cause, in this instance against the threat
of Persian invasion. The grace, confidence
and internal cohesion of the figure might
seem to mirror the coming together of
Greece herself. This figure, modelled on a
victor in the Panathenaea, was discovered
in the ruins of the Acropolis after the
citadel was sacked by Darius in 480 BC.

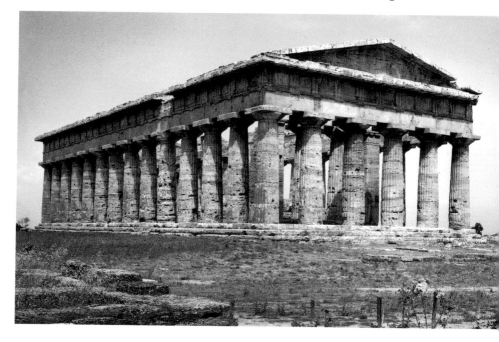

The Temple of Hera I, Paestum, *c*. 450 BC

The Greeks saw themselves as a mixture of two nations – the practical Dorians from the north and the luxury-loving Ionians from Anatolia. These strands, the first associated with sternness and the second with sensuousness, were epitomized in the two earliest and principal architectural Orders, the Doric and the Ionic. (An 'Order' in architecture refers to a standard form of column, with its base, capital and the horizontal beams or entablature it supports.) The Doric seems to have been thought the most appropriate for outlying 'colonies' like Paestum, where authority rather than grace needed stressing. The general structure of all Greek temples evolved gradually over several centuries, the idea being to give expression to the nature of the gods whose cult images they sheltered. These structures eventually came to summarize the order that the Greeks found in nature and in mathematics. They reflected the belief of the Ionian philosopher Pythagoras who saw numbers and geometry as a key to, and expression of, the divine. Here at Paestum, in this best preserved of all Greek temples, we find a rare survival of an inner double colonnade, one column placed on top of another, a device designed to hold up the original wooden roof, long since perished.

Flagon from Basse-Yutz, Moselle
Early fourth century BC
Bronze, coral and enamel
Ht 38.7 cm

The name 'Celt' is derived from a Greek word once applied to barbarian peoples living north of the Alps. They appear to have migrated westwards across Europe, sometimes settling in areas near to easily accessible iron ore deposits. Though normally associated with La Tène in western Switzerland, the present flagon appears to have been made in the Rhineland. What little is known about these early peoples suggests that they were fierce and pleasure-loving. Wide-ranging influences have been detected in their art, extending from Scandinavia to the Asiatic steppes. However, the most frequently cited sources are associated with the art of Archaic Greece (c. 600–500 BC), perhaps known to the Celts through the Etruscans of northern Italy. The present vase was carefully planned and can hardly have been conceived as an everyday object. Its decoration appears to combine Greek motifs with stranger material, perhaps derived from Scythian sources. The body of the flagon is of bronze and the admirably restrained areas of decoration are of coral and enamel. A small duck poised at the tip of the spout, apparently being chased by the dog-like beasts that form the handle, could suggest a humorous intention.

**Shield from the River Witham,
Lincolnshire
Third century BC**
Bronze
Ht 113 cm

It is possible that this shield was placed in the Witham with the intention of honouring or influencing a supernatural power. This is suggested by its excellent condition: it is beautifully made and has apparently never been used in battle. Such an explanation would be in line with the propitiatory religious rituals practised by many northern European tribes. Each half was hammered out from a single ingot of bronze and these were then riveted to the midrib. The metal was probably fixed to a wooden or leather backing and there seems to have been some applied decoration on the face – perhaps the image of a boar. The repoussé work was enriched with delicate engraving involving energetically conceived spirals. In general, the pattern work suggests a careful balance between asymmetrical and symmetrical features and recalls the interacting currents set up when some viscous liquids are stirred. It is tempting to see the ornaments that connect the outer bosses with the central stem as formalized duck heads, for water birds played a role in a number of early mythologies.

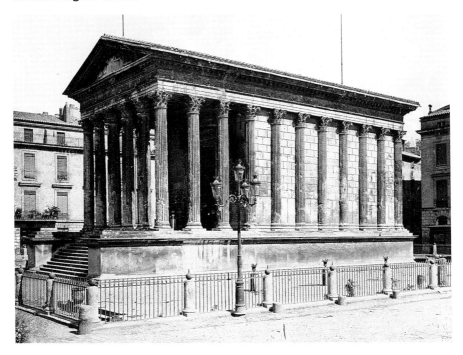

Maison Carrée, Nîmes, *c.* 16 BC

While Greek buildings expressed the religious beliefs of their creators, Roman ones were usually feats either of showmanship or engineering, sometimes of both. Here at Nîmes, not far from one of the most extraordinary works of Roman engineering (the famous Pont du Gard aqueduct), we find a work of civic architecture, designed one might suppose to impress a subject people. The building uses the relatively late Corinthian Order, rarely used by the Greeks. When the latter did use it, it was reserved for the innermost parts of their temples where, half-hidden in the darkness, the leaf-capped columns must have seemed like evocations of natural energy. Here, however, the Order is used rather ostentatiously on the outside of the building. It is customary to see the majority of Roman builders as vulgarians, but that is to judge them in the light of their Greek predecessors. Their works are at one with a nation that ruled almost all the known world from Hadrian's Wall to the Upper Nile. Whether imperialism and bureaucracy are to be cherished or not is another matter – and strictly speaking one outside the province of art history.

**Pastoral landscape from Pompeii
Before AD 79**
Fresco transferred to panel
51.5 x 49.5 cm

This is one of many similar scenes that once decorated the homes of predominantly middle-class Roman and Graeco-Roman citizens. It was probably painted after the major earthquake that devastated Pompeii in AD 63 and before the town was destroyed by the eruption of Vesuvius in AD 79. Such sacred idylls, executed in an impressionistic manner, are usually connected with a way of life much lauded by the poets Virgil, Horace and Ovid. However, the notion that a retired official (pensioned off by a grateful state?) would find some kind of pious contentment working the land and tending his flocks is perhaps something of a myth. At the time these works were conceived, slave labour was widespread and it is probably a hapless victim of this trade who is seen here apprehending an errant ram, lest it defile his master's mountain shrine! Some may be surprised by the painter's ability to use both linear and atmospheric perspective. The possession of such skills by journeymen painters raises a question concerning what may have been known about these sciences in distant antiquity.

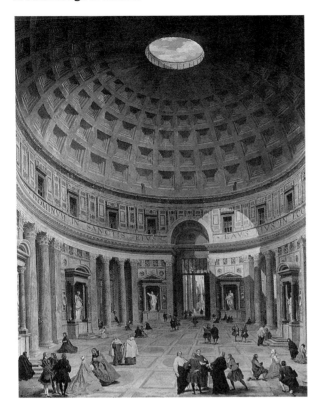

The Pantheon, Rome
AD 118 – 28
As painted by G.P. Panini
in 1749

The traditional rectangular temple could be described as outward-looking. The Pantheon, however, was the first major building to be conceived as an inner space and it became an object of envy for architects down the ages. This temple, dedicated to all the gods, reveals the mind of a poet and puts in perspective the claim that the Romans were no more than engineers. The whole place seems to have been conceived as a gigantic planetarium. The central 'eye', the only source of light, was thought of as the sun and there were originally bronze stars set into the coffers of the dome. The central space is exactly as wide as it is high – 43.4 metres – and in order to support the enormous weight of the dome the walls are some 6 metres thick. The structure is built from concrete composed of carefully graded aggregates, strong basalt at the base and the comparatively light porous pumice above. In this painting by Panini we can see the marble cladding as it was before modifications made in 1747.

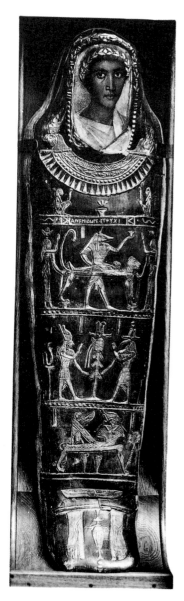

**Mummy case with painted mask, Egypt
Second century AD**

The power of the Roman Empire began to decline well before the end of the second century; around that time many intelligent people came to doubt man's ability to master the world and even questioned the purpose behind such an endeavour. This decline in confidence is first seen in the art produced in the more distant parts of the Empire and the style that resulted is known as the 'sub-antique'. This mummy case belongs to someone who died in the Roman province of Egypt and who was embalmed according to local custom. The skilfully painted face shows eyes that seem to look through us and far into the distance, as if the subject were contemplating at best another world and at worst an eternal void. The inscription below the portrait may be translated as 'O Artemidorus, farewell'. That stare will be seen again in succeeding centuries – some, indeed, have seen it as typical of the Middle Ages. There are many surviving mummy-case portraits from around this time (all with that same abstracted focus), mostly from Fayum in Upper Egypt. The technique used involved heating and fusing coloured wax.

**'Christos Helios' mosaic in
the necropolis under St
Peter's, Rome
Mid-third century AD**

This is part of the earliest Christian mosaic that has so far been discovered, and it shows
a curious mixture of pagan and Christian symbolism. The vines, familiar from pictures
representing Dionysus, have become the True Vine of Christ referred to by St John. In the
centre of the vault is a charioteer from whose head rays shoot out, leading one to think of
Apollo or some deified emperor driving his chariot across the heavens. Here, however, the
rays take the form of a cross and the figure holds an orb, a symbol of dominion. A celebration
of the daily rising of the sun has been transformed into an image of the ever-risen Son of
God. Whether or not the artist has been especially clever in constructing this curious dual
image is open to debate. The chances are that, trained in the antique tradition, the mosaicist
had no model to work from other than a pagan one and simply adapted a picture of Apollo to
suit his purposes. Most artists at this time were tradesmen and would have been obliged to
use patterns that had been handed down from one generation to the next.

**Arch of Constantine,
Rome
AD 312–15**

Below (detail):
**Constantine addressing
an audience**

This arch was built to celebrate Constantine's victory over a rival for the throne. It is an assemblage of items originally designed to commemorate the achievements of others. The roundels (each 2.3 metres in diameter) are taken from a monument to Hadrian and only the frieze below them is truly relevant to Constantine. This shows the first Christian Emperor speaking from a rostrum and flanked by statues of his predecessors, all ranged against a background of arches raised in honour of yet more emperors. The audience, whom one would have expected to be facing Constantine (and thus be seen from the back), are mostly shown from the side. It is as if the sculptor wanted to tell us something about the essence of the event, rather than show us mere appearances. How else could he have shown that Constantine was addressing the crowd while his auditors discussed what he said? Is this arrangement due to the sculptor's ineptness or are we witnessing a change in the way artists chose to relate the truth at the heart of an event? The detail shows the sculpture over the left-hand arch and gives some idea of the rather crude nature of the carving. Could it be that incompetence here goes hand in hand with insight?

Mosaic in the vault of the so-called Mausoleum of Galla Placidia, Ravenna, mid-fifth century

The cross, now familiar as a powerful symbol, was less well known during the first four centuries of the Christian era. Its prominence in art was encouraged by the alleged discovery of the True Cross some time before AD 337. Here, then, in a tiny mausoleum (approximately 10 x 11.8 metres) we find an even smaller vault, teeming with golden stars, all arranged so that they form not only one concentric pattern but interrelated arcs which seem to set up a pulsation around the cross. This vault is in the form of a hemisphere, but the outermost stars are bigger than the central ones, which creates the illusion that the 'dome' is deeper than it really is. The ambiguity leads the observer to see the cross suspended in an indeterminate space. This might be seen as an early example of Op Art, though here the intention appears to be to engender a rather structured reverence. Was the mosaicist cunningly manipulating the observer or did this image spring – all but unbidden – into the mind of a craftsman overwhelmed by the central emblem of the new faith?

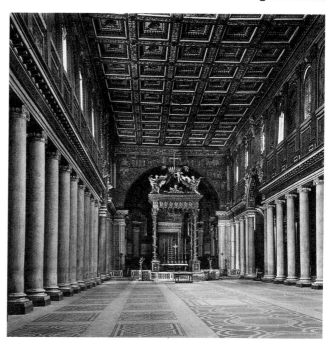

Sta Maria Maggiore, Rome, *c*. 432–40

Before Constantine left to found his new capital in Byzantium he started a fashion in church building, especially in Rome. As his standard form he chose that of the 'basilica', developed from the colonnaded secular halls used originally in the administration of justice, the remains of which are found throughout the Roman world. These new buildings had a nave, side aisles, transept and chancel – a pattern that was to endure. When Rome began to recover after its devastation by the Goths, there was an architectural revival in the old capital. The prime instigator of this mini-Renaissance was Pope Sixtus III, who lost no time in dedicating a major church to Mary, recently pronounced 'Mother of God'. Here his building is basilican in general form. Above the columns are rows of mosaics, the oldest surviving biblical narrative pictures, and they seem to be based on book illustrations that are now lost. Their theme is Eucharistic and the panels are arranged so that the sequence leads one down the spacious nave towards the high altar. This altar, which actually belongs to a later period, is framed by a kind of triumphal arch. The mosaics on this arch tell of the life of the Virgin and are mostly derived from sources now excluded from the canonical scriptures.

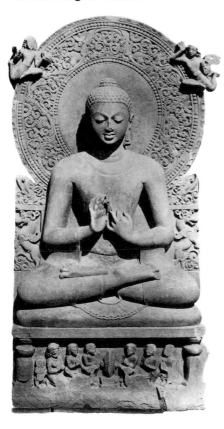

Seated Buddha from Sarnath, India
Fourth or fifth century
Chunar sandstone
Ht 160 cm

Buddha is said to have delivered a sermon to some of his disciples who, shocked by his abandonment of bodily mortification, had previously deserted him. He is shown here teaching them in the Deer Park at Sarnath, seated on a lotus flower and in the act of 'setting in motion the wheel of the law'. This he signals by the hand gesture known as the *Dharmacakra Mudra*, and an image of this wheel appears like a halo behind his head. It expresses the Four Noble Truths, which have to do with the nature of suffering, and the Noble Eightfold Path, which leads to Enlightenment. This last state is one with Nirvana, a condition involving the loss of selfhood, which a certain Gautama Siddhartha had obtained in the course of forty-nine days of unbroken meditation. It was this feat that led to his being called 'Buddha', a word that means 'the one who is fully awake'. The crest at the crown of the Buddha's head is known as *ushnisha* and testifies to his attainment of Enlightenment. His elongated ear lobes were caused by his having once worn heavy princely earrings, but they later came to signify his wisdom.

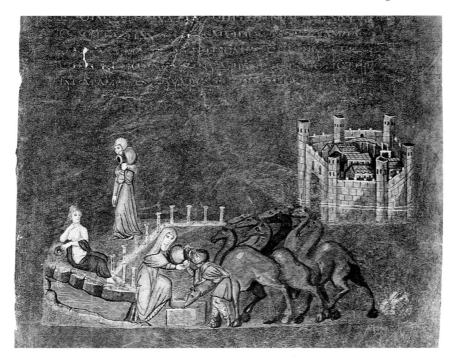

The 'Vienna Genesis'
Sixth century
Body colour with silver script

Manuscripts were once written on papyrus which disintegrated with age. They were usually made into scrolls and were often copiously illustrated, the pictures being arranged like a frieze and in parallel with the text, somewhat in the manner of a modern comic strip. Books made from animal skins began to replace these cumbersome scrolls at the end of the first century and there is evidence to suggest that many richly decorated codices (manuscripts bound in the form of books) were made in the next three centuries, though virtually nothing survives from this period. The 'Vienna Genesis' may reflect this lost tradition. The text is written in silver on parchment dyed with costly purple, but less than one-sixth of the original remains. The illustrations suggest that the old comic-strip format has partly survived, for in this illustration to Genesis 24 'Rebekah' appears twice (as she might in a continuous frieze). In keeping with the story she seems to be a model of courtesy, for she not only gives water to a servant whom she meets on her way but also to his camels. In accordance with a Roman tradition the river is personified by a female who continues to replenish the stream from a notionally bottomless pitcher.

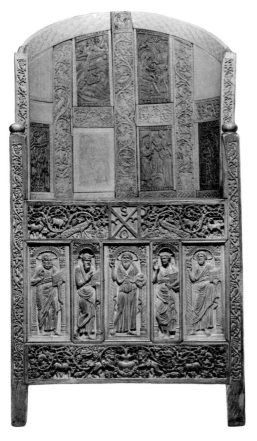

Maximian's Chair
c. **547**
Ivory
Ht 150 cm

Justinian, perhaps the greatest of the
later Roman emperors, ruled from the
Eastern capital, Constantinople. He was
nevertheless keen to keep a strong grip
on Italy through his close association
with Ravenna. He sent gifts to enrich at
least one of the major churches, seeking
to make the city an image of his own rich
capital. The present chair was probably
a gift from Justinian to Bishop Maximian,
whom he trusted to rule as viceroy.
Some of the ivory panels tell the story of
Joseph and the position of trust that the
patriarch had once held under Pharaoh.
The suspicion is that Justinian had this
Old Testament story included to make it
clear to Maximian that he expected the
same kind of loyal service from him that
Joseph had given to his Egyptian master.
It is unlikely that the chair was ever
intended to be used as a seat. In
keeping with Eastern traditions it may
have been carried in sacred
processions, perhaps supporting a
gospel book resting on a fine cushion.
It was probably conceived as a sign of
the Emperor's divinely given authority
reaching out to his favourite dominion
across the seas.

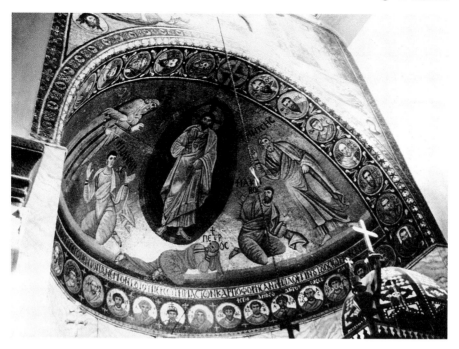

The Transfiguration, apse mosaic in the monastery of Saint Catherine, Mount Sinai, after 548

Justinian built a church on Mount Sinai that was to be at the heart of a defensive system, 'so that the wild Saracens might not be able to take advantage of the district' (Procopius). Since most of the mosaics that once enriched Constantinople have perished, this is virtually the only evidence of what the Emperor's workshop could achieve. The picture represents a summary of what the Byzantines understood of their faith. Here is the moment when Jesus was revealed by God to be His only son. Moses and Elias have appeared as witnesses, and three of Jesus's friends are overcome with awe. Those first three earthly witnesses are joined in the medallions below by the rest of the Apostles, sixteen Prophets, King David and two incumbents of the Church. In the spandrels above there are medallions of Christ's mother and of John the Baptist surmounted by angels who are pointing to an *Agnus Dei*, an image of Christ as sacrificial lamb. The entire scheme goes hand in hand with the Byzantines' claim to be the custodians of divine revelation.

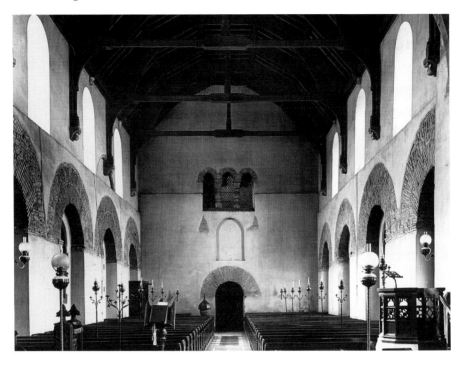

All Saints, Brixworth, Northamptonshire, *c*. 680

When the Romans left Britain towards the beginning of the fifth century, the country was already partly settled by Saxons, who were soon joined by many of their continental brethren. Christianity was established early on, but not without dissension between different traditions and many setbacks due to repeated pagan incursions. In these turbulent times churches served as strongholds as well as places of worship. This church was built by monks from Peterborough, and they may have seen it as a vantage point from which to organize the conversion of pagan Mercia. The builders used materials taken from a nearby Roman villa and tried to emulate what they knew of the great Christian basilicas in Rome. If Wilfrid of Hexham was involved, as has been suggested, it would explain the presence of several Roman and Syrian features, for the Bishop was widely travelled and was a staunch supporter of Roman Christianity. There are signs that there was once a three-arched division between the chancel and the nave. The triple opening high up on the west wall (pictured here) forms a kind of tribune and connects with a ninth-century tower room. From there a sacristan might have kept watch over the altar and its treasures.

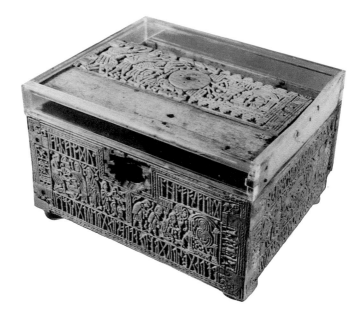

The Franks Casket
c. **700**
Whalebone
10.5 x 23 x 18.5 cm

Part of this box is now in Florence. The entire object was probably made in Northumbria when the region was enjoying a burst of creative energy encouraged by the coming together of Celtic and Roman Christianity. The five scenes taken together represent a hotchpotch of scholarship, and the inscriptions are in runes and Latin. The lid and part of the front depict episodes from the story of Wayland the Smith, while the rest of the front shows the Journey of the Magi. On the left panel we see Romulus and Remus being nourished by a she-wolf (obligingly lying on its back!); on the far side there is a depiction of the capture of Jerusalem. The story on the right side is a mystery but seems to relate to the Siegfried Saga. The model for the back panel may have been an illustrated Chronicle of the World once owned by a Northumbrian bishop, but the style of the carving and the general interest in heroic conflict seem to come from Pictish monuments. The scholarship formerly associated with Rome has passed to a once distant outpost of her Empire, though the general air of naivety and excitement would hardly have found favour in that city.

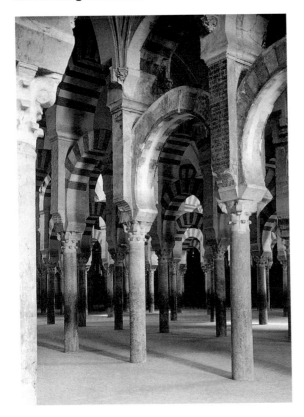

The Great Mosque (now the Cathedral), Cordova Begun c. 785

Islam was founded in the seventh century and its dominion spread rapidly during the following four centuries. Strictly speaking, Islamic artists were forbidden to represent human and animal forms, a prohibition that encouraged them to invent increasingly complex patterns of surface decoration, generally referred to as 'arabesques'. So great was the Muslim expansion that the scholars of the Byzantine West began to emulate Islamic restraint and instituted a period of iconoclasm (a movement that forbade virtually all religious imagery) in their own art. However, these restrictions were not seen as negative by Muslim artists, and the patterns they created, often involving the most sophisticated geometry, were essentially theocentric, proclaiming Allah's very presence. Moreover, this interest in formal design can be seen in their architecture, and the buildings that emerged show great invention. Here we see part of the hall, containing some 120 columns, that constituted the starting point for four successive enlargements. The culmination was reached in the tenth century when this Friday Mosque achieved a plan larger in area than any Christian cathedral. The colonnades rise one on top of another and support a wooden roof. The columns are of varying design and in some cases the builders made use of items pillaged from conquered Roman and Byzantine sites.

**The Palace Chapel, Aachen
Late eighth century**

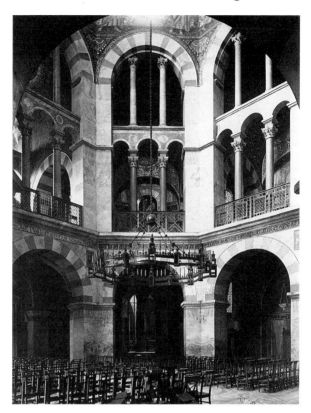

The Christian West set much store on reverencing things and places with holy associations. With this type of 'sympathetic magic' (see p. 55) it seems that one could be especially blessed by possessing something that had been involved in holiness. Hence, when a Frankish King wanted to build himself a palace, he chose a site where a piece of a cape (known in Latin as a *cappa*) belonging to St Martin of Tours had been honoured. This new palace therefore became known, again in Latin, as the Capella Palatina – from which we derive our word 'chapel'. St Martin's cloak fell on the King's shoulders in another sense, as that palace became the centre from which he set out to rule and Christianize the old Roman world. He sought to found what his scholars called a *Roma Secunda* – a second Rome. In keeping with these high ambitions, his architect, Odo of Metz, based this palace chapel on one of the splendours of Justinian's Ravenna, S. Vitale, and also perhaps upon the ancient circular temple of Minerva Medica in Rome. The Frankish King was known as Carlus Magnus – Charles the Great, pronounced 'Charlemagne' by the French. He crowned himself in front of the Pope in Rome to become the first Holy Roman Emperor.

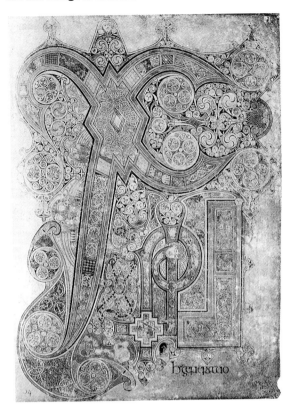

**The Incarnation Initial, from
the Book of Kells
First decade of the ninth
century (?)**
Gouache (?) on calf vellum
33 x 24 cm

This most sumptuous of all surviving Hiberno-Saxon manuscripts may have been illuminated
on the island of Iona, though its form could have been influenced by splendid manuscripts
from the court of Charlemagne. At this time, writing and illumination were so expansive that
whole Bibles were rarely attempted, as they would have been too heavy to handle. Gospel
books usually contained several full-page illuminations, which included 'portraits' of the four
authors, 'carpet pages' (pages decorated with an all-over pattern, often characterized by
much interlace ornament), sets of concordances (known as Canon Tables) and sometimes a
few illustrations to gospel stories. Some of the pictures may draw on sources from that lost
tradition of early biblical pictures mentioned on p. 73. There are also some initial pages, of
which this is perhaps the finest. It marks the beginning of an account of what Christians
believe the most important event in history. It includes the sacred monogram associated with
the name of Christ, the letters X, P and I. They burst across the page and embrace a wealth
of naturalistic detail, including three human figures, minutely observed birds, moths, cats,
mice and even an otter eating salmon.

LXXII DEFECERUNT LAUDESOOFILIIES SEPSALOOUSASA

Illustration to Psalm 73, from the Utrecht Psalter
c. 820
Brown ink on parchment
10.8 x 21.6 cm

Charlemagne's scholars searched Europe for every book and scroll of Classical and early
Christian learning and began to copy them, often in a free interpretation of an 'antique style'.
We owe these copyists an immense debt, for without them much early scholarship would have
been lost. Here a scribe has copied and embellished a book of Psalms. The simulated
ancient style with its busy figures was to fascinate and form a model for British scribes for
centuries to come. It is not clear whether these very literal interpretations of the Psalms are
Carolingian or 'Late Antique' (the style associated with the decline of Roman art, which can
still be detected in works dated to the sixth century and beyond), nor whether they represent
misunderstandings or good-humoured observations in the tradition of caricature. Perhaps
'fun' and 'faith' were not incompatible. An example of this literalism and/or good humour is
seen in the figure, top right, who seems to be assisted by a hand emerging from the clouds.
It illustrates verse 2: 'My feet were almost gone; my steps had well nigh slipped.' Another
remarkably lively detail shows a horse and foal illustrating verse 22: 'So foolish was I, and
ignorant: I was as a beast before thee.'

David Composing the Psalms, from the Paris Psalter
Tenth century
36 x 26 cm

When the Byzantine ban on images was lifted (see p. 78), there was a great rebirth of interest in the ancient Classical styles of painting. Illuminated books, icons and mosaics were produced in abundance and these mark the beginning of what has been called the 'Macedonian Renaissance'. In this frontispiece we see David, the writer of the Psalms, sitting before a tree playing his harp. However, the patriarch is surely a thinly disguised version of the Greek god Orpheus (with muses in attendance) – the latter's lyre has simply been exchanged for a harp. Even the animals (especially the morose dog at the Psalmist's feet!) bring to mind pictures of that ancient god in his role as tamer of wild beasts. The 'impressionistic' rendering of the landscape seems very close to the kind of work that has been preserved in such Pompeian frescoes as that discussed on p. 65. The existence of this picture and many like it poses the question as to whether they were truly inventions of the ninth century or copies of ancient prototypes unknown to us, possibly created in those 'lost centuries' mentioned on p. 73 in regard to the 'Vienna Genesis'.

St Philibert, Tournus
c. 950–1120

Despite all the lawlessness of Dark Age Europe, certain Roman building skills survived. Travelling teams of masons began to revive these crafts and gradually a style emerged: the Romanesque. The Church of St Philibert is so called because it houses the bones of that sixth-century saint. His remains had formerly resided at two sites on France's western seaboard, but these were raided by Norsemen, and the first Burgundian monastery to which they were taken for safety was subsequently attacked by Hungarians from the east! To ensure lasting safety, here as elsewhere, it was necessary to design a building that was virtually fireproof: this required a stone vault, suitably massive walls and some knowledge of structural engineering. In the experimentation that followed, the builders at Tournus were notable pioneers, though their solutions were not altogether typical. Here, superbly dressed stone piers support the nave arcade and smaller half-round columns in their turn provide the springing for diaphragm arches. These arches then take the thrust of transverse barrel vaults. Inside and out the building has the appearance of something between a well-built castle and a Roman basilica; in this at least it is fairly typical of many other churches of the tenth and eleventh centuries.

**The New Minster Charter
After 966**
28.8 x 16.2 cm

Monasteries gained in importance throughout the tenth century. This was partly due to the alliance between Church and state sparked off by Charlemagne's coronation before the Pope (see p. 79). A close association between powers temporal and spiritual could be seen in England when King Edward the Elder, son of King Alfred, gave orders for the building of the New Minster at Winchester. Several English kings and prominent ecclesiastics had close ties with continental courts or monasteries and they were responsible for introducing Carolingian tastes and attitudes to England. In this manuscript, produced by the monks of Winchester, we see King Edgar, 'King of All England', presenting a charter to the New Minster to celebrate the introduction of Benedictine monks there. The luxuriant acanthus leaves that seem to burst out from their trellis-work frame show a strong influence from the monastery at Metz, while the figure of the King recalls work from Tours – both were important Carolingian scriptoria. A hint of understandable euphoria can be seen in the way the King twists ecstatically in the presence of a beatific vision.

**Rheims Cathedral (west front)
1225–50**

Twin towers have played a major part in the articulation of cathedral façades since the ninth century. Originally they helped to support a western tribune or gallery over the entrance, whence a dignitary might keep watch on proceedings or receive tribute. However, the entire western façade was to become the subject of much invention. It usually hinted at the nature of the structures that lay behind, but above all else it provided a massive showcase, setting out the twin concerns of piety and allegiance required by Church and state. Notre Dame at Rheims was the French coronation cathedral and it is not surprising to find that a coronation scene, in this case that of the Virgin Mary, should take pride of place in the gable above the central portal. The pinnacle above this scene reaches up to the centre of the enormous rose window which gives light to the nave, uniting interior and exterior. The figure sculpture found in the various jambs, buttresses and friezes, much of it of superlative quality, is concerned with stories relating to Old Testament royalty. High up on the façade there are fourteenth-century statues of the kings and queens of France extending back to Merovingian times.

The Chichester Roundel
c. **1260**
Fresco secco
Dia. 76.2 cm

The origins of the Gothic style in painting are found in association with the cult of chivalry and elegance, something much in vogue at the court of Louis IX of France (1214–70). Religious men were eager to accord the Virgin Mary a high place in their devotions, very much in line with the cult of courtly love. The English prelate, Henry of Chichester, seems to have been particularly moved by the thought of the otherworldliness and purity of that saint and had himself painted in his own private Mass book, kneeling at the feet of his most gracious Queen of Heaven. However, the practice of manuscript illumination and wall-painting went hand in hand at this time, and there is evidence to suggest that the latter was more highly esteemed. Unfortunately, almost all the wall-paintings were destroyed in the iconoclasm (the destruction of images) of the sixteenth century. This relatively tiny panel is especially precious as it has preserved something of the tenderness and elegance that may have been found in countless large-scale images of the Virgin.

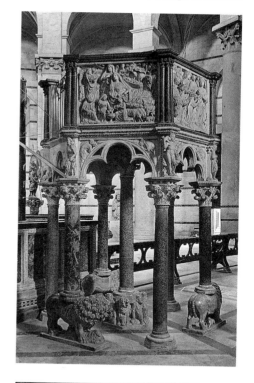

Nicola Pisano (*c.* 1220/5 – *c.* 1284)
Pulpit in the Baptistery, Pisa, 1250 – 60

Below (detail):
The Adoration of the Magi

This pulpit was carved when Pisa, having
won major victories, was still enjoying its
power. Like her ally Venice, it was a centre
of world trade. Architects and sculptors
seemed especially well placed to meet the
demands of patrons, as there was an
endless supply of marble in the nearby
mines of Carrara. Despite his name,
Pisano did not come from Pisa but from
Apulia, where he would have come into
contact with southern Italian sculpture and

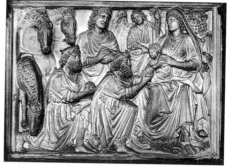

may have learned something of Italy's Classical past. With these facts in mind one may see
why Pisano (and the team of sculptors who worked with him) should have sparked off
a development in sculpture that some have seen as the first hint of the Renaissance which
was to blossom a century or so later. In the *Adoration* we can see suggestions of Roman
sculpture (there was, and is, a collection of such work in Pisa), especially in the figure of
the Virgin Mary, who has something of the noble air of a Roman matron, and in the restless
horses that have followed the Magi to that chubby Italian *bambino*.

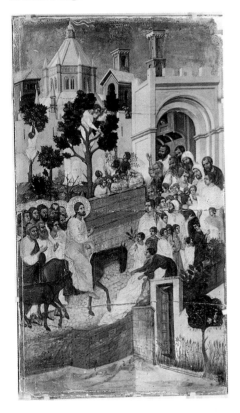

Duccio (*c.* 1260–*c.* 1319)
***Entry into Jerusalem*, from *Maestà*, 1308–11**
Tempera and gold leaf on panel
103 x 57 cm

The present picture is one of twenty-six that form the reverse of a very large painting of the Virgin and Child surrounded by saints and angels. It was commissioned as a replacement for an earlier Madonna, which, according to the Sienese, had helped in its capacity as a votive picture in the defeat of the Florentines some fifty years earlier. The panels at the back tell the story of Christ's Passion and several of them could illustrate scenes known to have been acted out in the streets of Siena from the beginning of the century. The *Entry* scene has many similarities to a Byzantine mosaic in the Capella Palatina at Palermo and, if the appropriate pattern books could be found, it might be possible to show that Duccio had worked from the same model. However, the 'temple' in the background seems to suggest that the painter had some knowledge of a Romanesque baptistery like that of Florence. Furthermore, Christ's progress into the city of Jerusalem is set in a street that has a great deal in common with those of the hill-town of Siena.

**The title page of volume one of a
Koran in seven volumes, 1304**
Gouache (?) on paper
47.5 x 32 cm

The word *Koran* means 'recitation' and for the most part the book's text is given in the first person as the voice of God. There is a tradition that the text exists eternally in heaven and that it was handed down to Mohammad, portion by portion, by Gabriel or a holy 'Spirit'. On the opening pages of the present volume there are words taken from chapter 56, verses 77–80: 'Most surely it is an honoured Koran, in a book that is protected; None shall touch it save the purified ones. A revelation by the Lord of the worlds.' Muslims take this to mean that the book may only be recited by 'honoured and great men' and that its textual purity is protected by the care with which it is written. Here, the central eight-angled stellar panel is inscribed with white Thuluth script meaning 'the first seventh'. The similarly white script in the upper and lower panels is Kufic. The colours are blue, orange, red and gold and a profusion of arabesques and trellis-work enriches the panels and borders. The last page contains a dedication to Rukn ad-Dīn Baibars, then High Chamberlain and afterwards Sultan Baibars II.

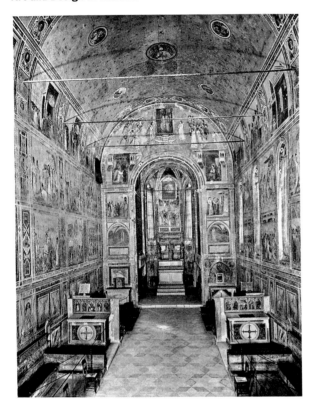

Giotto (*c.* 1266–1337)
Arena Chapel, Padua,
between 1304 and 1313

The growth of trade in the fourteenth century increased the practice of usury (lending money at interest), a sin then formally condemned by the Church. Enrico Scrovegni, heir to an income made in this way, seems to have founded the Arena Chapel as a means of expiating his father's guilt. Enrico's tomb was duly placed behind the altar and the two painted chapels on either side of the chancel arch may be intended to represent the resting places of Enrico and his consort. The walls are covered with narrative scenes illustrating the life of Christ and the Virgin, but Giotto has placed the story of Judas's conspiracy just above one of these fictive chapels. The close proximity between that chapel and a scene depicting Judas receiving the thirty pieces of silver, his monetary reward for treachery, may not have been accidental! The architecture of the two painted chapels has been rendered according to the laws of perspective, the centre of vision corresponding with a point just above the distant altar. While Giotto's knowledge of perspective theory may have been limited, he could still use it with great skill. The entire cycle is seen as the first firm indication of the Renaissance, which began in earnest a century later.

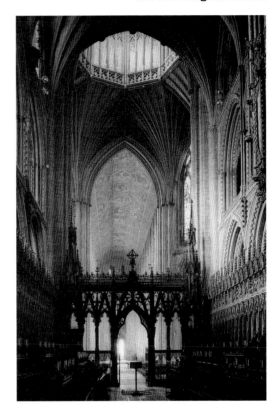

**The Octagon, Ely Cathedral
1322–40**

There are many accounts of collapses and fires affecting medieval buildings, sometimes soon after their construction. At Ely the four crossing piers fell, causing the great Romanesque tower to follow. In so doing it destroyed the first three bays of the newly constructed choir and much of the two transepts. This left an enormous hole at the centre and a problem for the prior! Teams of masons and carpenters were enlisted and eight new piers were erected to replace the four that had fallen. Having secured the use of some massive timbers (eight of the pieces were approximately 19.2 x 1 x 1 metres), the carpenters invented a highly complicated system of bracketing and bracing, which enabled them to span a 21-metre space and at the same time provide a support for an octagonal lantern tower. This structure was originally intended to carry a peal of bells and it continued to grace the Fenland landscape for over five centuries. Not until 1847 did the lead-clad timbers need replacing. Internally, the complicated supporting structures are hidden by timber work that simulates tierceron stone ribs. The whole episode was fortuitous as it signalled and strengthened advances in timber work, later to become a major feature in English Gothic.

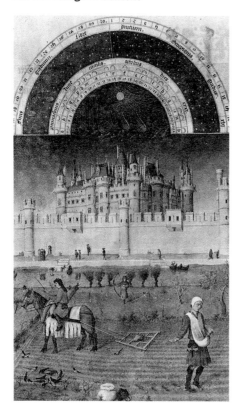

***October*, from the *Très Riches Heures*
of the Duke of Berry, *c.* 1416**
Gouache (?) on vellum
29 x 21 cm

This manuscript was painted some sixty years after Europe had been stricken by the Black Death, at a time of civil unrest and while France and England were embroiled in wars. It is as though the Duke and his favoured artists, the Limbourg brothers, were seeing the world through rose-coloured spectacles. The picture is one leaf from a book of private devotions that draws on a tradition established in the twelfth century. These costly manuscripts usually contained psalms, various devotions and also an illuminated calendar (traditionally associated with 'the labours of the months') and the signs of the Zodiac. Here the October sun is reflected from the walls of the castle (actually the Old Louvre, erected by the Duke's brother, Charles V), which rises on the right bank of the Seine. A field is being tilled and seed being sown. Meanwhile, a scarecrow, with bow and arrow poised for action against errant magpies, has his head turned in the 'wrong' direction. Does all this loving attention to an ideal world echo the dying strains of a past age of courtly love or could it be that the artists were half-aware of the rebirth that had already begun in Italy?

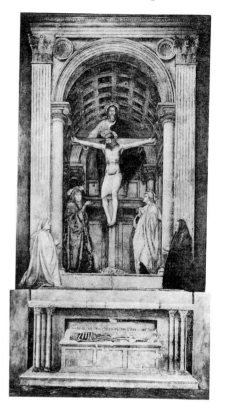

Masaccio (1401– c. 1428)
The Trinity, c. 1427
Fresco
667 x 317 cm

In complete contrast to such 'International Gothic' artists as the Limbourgs, Masaccio faces the stern and palpable facts concerning human existence – as he understood them. He presents a depiction of the three-person God of Christian theology in the light of a growing understanding of man's tenuous place in the universe. He involves us directly, tempting us to believe with this fresco that we are looking up into a chapel set into the wall. He is aware of a renewed interest in Classical Roman architecture and applies the mathematical rules that had recently been found to underlie monocular perspective. The work seems to have been commissioned by some members of a family of Florentine standard-bearers and one of these kneels 'this side' of the principal picture plane, as does his wife. They act as mediators between us and the Trinity, and in this they are aided by the figure of Mary who looks out at us while pointing to her crucified son. The entire scene is set above a fictive tomb with skeletal remains. There is no hiding here, either from the new-found interest in Italy's once noble past or from the ever-present realities of life and death. Masaccio himself apparently died in Rome at the age of twenty-seven shortly after completing this picture.

Donatello (*c.* 1386–1466)
David, 1430–33
Bronze
Ht 137.2 cm

Donatello is closely associated with Masaccio and with the architect Brunelleschi, major figures in the new movement that we now call the Renaissance. Donatello had already made his name when he visited Rome; there he studied all the antique sculpture that he could find. On his return to Florence he was commissioned by the ruling family to produce a *David* for the courtyard of their palace. It seems that the Florentines identified themselves with the slayer of Goliath, partly because of the domination that they experienced at the hands of such 'giants' as Milan. The youthful athlete seems to owe something to the cult statue of the god Antinous, likened by the Romans to Apollo, Dionysus and sometimes to Silvanus. The present statue was the first nude figure cast in bronze since antiquity and his lithe and sensuous body would have appealed to the new aesthetes of Florence. The commissioner, Cosimo de' Medici, has been compared to a latter-day Mafia *padre*, but he seems to have combined a shrewd head for business with genuine sensitivity and, above all, with an unerring and generous recognition of the talent he found in others.

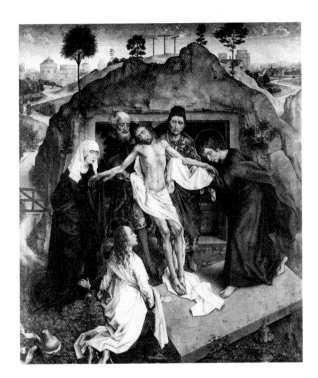

Rogier van der Weyden
(*c.* 1400–64)
The Entombment, c. 1450
Oil on panel
112.8 x 96.5 cm

Although oil had been known as a painting medium since antiquity, its use was immeasurably refined by Flemish artists in the fifteenth century. It enabled them to create pictures that combine a delight in minuscule detail with a translucence beyond the range of tempera and fresco painting. From Flanders this refined use of oils gradually spread to Italy; indeed, the present picture may have been instrumental in this trend. It seems to have come from the Medici collection and there is evidence to suggest that Rogier painted at least one picture specifically for that ruling family. The likelihood is that Rogier's acquaintance with Florence was a spin-off from a visit he made to Rome in the jubilee year, 1450. There is another hint that the present work may have been painted in Italy, for its composition is unlike that of any other *Entombment* emanating from Flanders, though it does strongly recall a picture associated with the Florentine master, Fra Angelico. From this time on, detailed distant views like those seen in Rogier's work are to be found in Italian painting with increasing frequency.

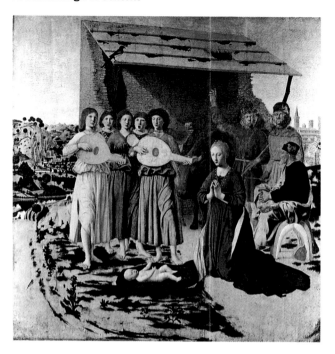

Piero della Francesca (1410/20 – 92)
The Nativity, c. 1475
Tempera (?) on wood
124.5 x 123 cm

The winding landscape on the left and the position of the Christ-child, lying apparently helpless on the ground, suggest that Piero was aware of the way Flemish painters treated Nativity scenes. In fact, the Fleming Joos van Ghent had worked at the court of Federico of Montefeltro where Piero was employed. Nevertheless, the cool morning light and the Olympian stillness may seem typical of the southern Renaissance. The choir of singing angels have something about them that recalls the Athenian Acropolis and the Caryatids of the Erechtheion. While these musings are subjective, they are supported by Piero's known interests. For example, he wrote a book on the 'regular' bodies (the basic geometric structures that some have thought to correspond to the 'essence' underlying all existence) and their supposed relationship to the human figure; interests of this kind lay at the heart of Greek civilization (see p. 61) and exercised the mind of Plato. It is as though Piero was attempting to connect the central fact of Christian theology, the Incarnation, with the calm rationality of Classical thought, as had St Augustine of Hippo centuries before.

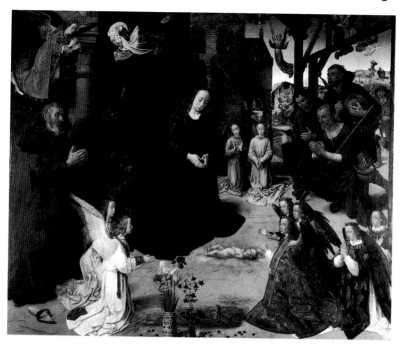

Hugo van der Goes (*c.* 1440–82)
***The Nativity* (the central panel of the Portinari Altarpiece), 1475/6**
Oil on panel
253 x 300 cm

The first record of Hugo concerns his becoming a Free Master of the Guild of Painters in Ghent, suggesting that he had been an apprentice for some five years. Such trade guilds were widespread throughout the Middle Ages and remained especially strong in the fifteenth century in Flanders, ensuring high standards of craftsmanship. Hugo's membership was sponsored by Joos van Ghent, whom we have already encountered at Urbino (p. 104). Many artists at this time were greatly affected by the spread of popular piety. In particular the works of St Bonaventure and St Bridget of Sweden were highly esteemed and it is clear from the writings of the fifteenth-century monk, Thomas à Kempis, that asceticism was prized – at least in theory. The recitation of the rosary had been promoted by some of the preaching orders and it may be (to take one example) that the fifteen angels in the present painting are a hidden reference to the Fifteen Mysteries of Mary involved in that meditation. The picture was commissioned by Tommaso Portinari, an agent of the Medici, working in Bruges. It was sent to Florence, together with two side panels depicting Tommaso and his wife, where it became very influential.

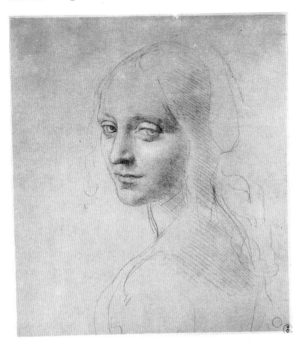

Leonardo da Vinci (1452–1519)
Study for the Head of an Angel, c. **1482**
Silver-point
18.2 x 15.9 cm

Throughout the Middle Ages painting was seen as a craft and paintings were often most valued for the cost of the materials used and the type of subject treated. While many artists seemed to enjoy a good working relationship with their patrons, they were nevertheless essentially hired servants. These bonds became slightly less obvious in the fifteenth century, particularly in Florence, where the most gifted artists began to assert their independence. However, it was Leonardo who broke most notably with the tradition of servitude. Such recognition and financial support as he needed were obtained by working for a number of patrons, some secular and others ecclesiastical. He seemed to be obsessed with the desire for a truth that went beyond all the conventional categories, whether theological, scientific or artistic. This passion led him into the widest speculation, where the research conducted seems as important as the ends obtained. The present drawing is a study for the head of an angel for his *Virgin of the Rocks.* He seems here, as elsewhere in his work, to show a moment in time, and in this anticipates an interest of the Impressionists.

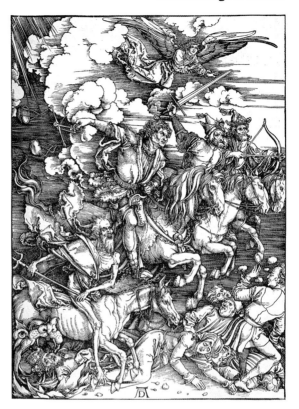

Albrecht Dürer (1471–1528)
The Four Horsemen, from
The Apocalypse, 1498
Woodcut
29.2 x 27.9 cm

The invention of movable type in the fifteenth century heralded a tremendous advance in the spread of knowledge and is associated with a general increase in intellectual freedom. Woodcuts had been used previously, but they were given greater currency as more printing establishments went into production. While painting was almost entirely given over to portraiture or religious subjects, woodcutting and line engraving allowed artists to experiment with new picture types and to exercise their own fancy. In *The Four Horsemen* Dürer has given his own version of the story told in the Book of Revelation, chapter 6. There the white, red, black and 'pale' horses appear separately, symbolizing war, conquest, famine and death. However, Dürer has chosen to show these riders thundering over 'the fourth part of the Earth' as a dreadful team. He conceived his picture when the Reformation was on the point of dividing Europe and as the old imperial order was about to break up. Strange apparitions were seen in the skies around this time and, not long after, there was an outbreak of the plague in northern Europe. Dürer would seem to have reflected the troubles of his own time and may even have predicted some of those yet to come.

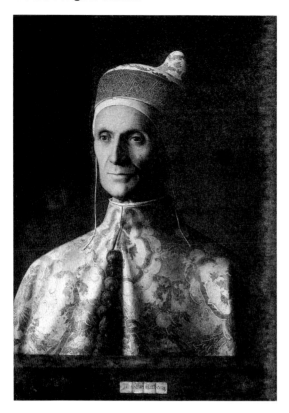

Giovanni Bellini (*c.* 1430–1516)
***Doge Leonardo Loredan*, *c.* 1502**
Oil on poplar wood
61.6 x 45 cm

Venetian painters were among the first to take up and develop the new oil painting techniques that had been widely used in Flanders. Here Bellini adopts yet another Flemish practice, that of the three-quarter view portrait reminiscent of works by Van Eyck and Van der Weyden. Venice had been one of the greatest centres of world trade since the Middle Ages and reached the peak of its power in the fifteenth century, when it commanded an empire on the mainland. A complicated system of government involving some two hundred senators and a council of ten was watched over by the doge, a kind of chairman whose election was carefully devised to prevent any possibility of self-seeking or corruption. Leonardo Loredan served the city from 1501 to 1521 and is seen in Bellini's portrait to combine kindness with firmness. The wealth and political stability of the empire is reflected in the Venetian arts, more especially in the painting of the sixteenth century. There is a warmth in Venetian painting virtually absent from the work of all the other Italian city-states.

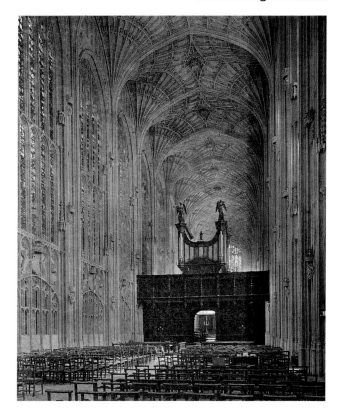

King's College Chapel, Cambridge 1446–1515

The present chapel was founded by the pious but ill-fated Lancastrian, Henry VI, and finished during the reign of an altogether more assured Tudor, Henry VIII. The Wars of the Roses blighted political life for some thirty years, but despite this England's trade blossomed, due largely to wool exports. This commerce prompted wealthy and grateful merchants to endow many new churches. Advances in civil liberties encouraged the growth of guilds of craftsmen, ensuring among other things that the building trade prospered. Thus masons and carpenters began to develop the traditional Gothic, largely the invention of the French, into something that can now been seen as quintessentially English – the 'Perpendicular' style. Yet another trend of this time was towards an increase in secular learning, due in part to the invention of printing and, rather later, to the suppression of the monasteries. All these matters find an echo in the present chapel. While so many churches had been designed to satisfy the needs of a sacramental and hierarchical religion, King's College Chapel is eminently suited to the dissemination of the Word and the education of God's people.

The Stone of Tizoc
Fifteenth century
Dia. 275 cm

The Aztec and Mayan civilizations came to an abrupt end with the arrival of the Spanish in Central America. All that we know with any certainty about these indigenous peoples is derived from native legends, illuminated manuscripts, sculpture and the research of archaeologists. The present massive carved stone commemorates the reign of a fifteenth-century Aztec ruler. The images must have seemed totally alien when first presented to Western eyes. The top surface is a 'solar disc' which appears to draw on a tradition of calendar representations stretching back thousands of years. Here, though, the subject is more concerned with cataclysms, past and yet to come. It seems that the lower part of the stone was conceived as a 'lunar disc' and that the collapse of the upper onto the lower disc would signify the end of time. All that keeps these cosmic forces apart is the band of warriors who, led on by their ruler god, bring the less fortunate into submission and ultimately to human sacrifice. Aztec carving tends towards surface decoration, a characteristic that has been held to reflect their settlement in the relatively flat central Mexican plateau.

**Albrecht Altdorfer
(*c.* 1480–1538)
St George, 1510**
Oil on lime wood
28.2 x 22.5 cm

Almost all the landscapes painted from Roman times through to the late fifteenth century had been adjuncts to figure subjects, and sometimes simply space-fillers. An interest in these scenes was even considered unworthy by some and when they were included they were usually idealized to the point where many seem tame and domesticated. The discovery of the New World, increasing travel and some weakening of traditional cosmologies may have contributed to a change in attitude towards the natural environment. Altdorfer was, with several of his German contemporaries, among the first to take an interest in landscape as a subject in its own right, and for him it was the sheer profusion of nature that captured his imagination. Here, St George, all but lost, scarcely needs a dragon, for this northern forest is strange enough to inspire the wildest of fantasies. Such a scene may have been experienced by Altdorfer on some Alpine journey made from Regensburg, where he later became city architect and councillor. There is an air of romanticism here which one might think more appropriate to a later age.

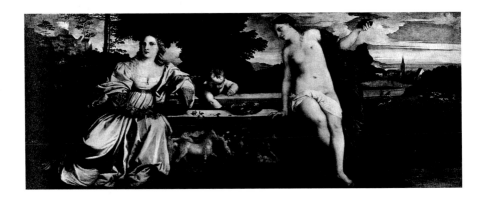

Titian (d. 1576)
Sacred and Profane Love, c. 1511
Oil on canvas
275 x 170 cm

In 1500 an Academy was set up in Venice to renew Greek philosophy, much as had been attempted earlier in Florence. Hence, many Venetian paintings were given hidden meanings so that they might appeal to scholars. One of the chief concerns of these 'philosophers' was to demonstrate a connection between certain pagan rites of initiation and the concept of virtuous Christian love. The original title of the present picture is not known, but it seems to contrast two forms of love. The naked figure, as can be guessed from her 'body language' and juxtaposition with a church, is in the ascendancy, while the clothed figure seems to be troubled and a type of worldly vanity. The well-head on which they sit could be a fountain of love, for the waters are stirred by a Cupid. The sculpted frieze shows a frenzied horse, symbol of unbridled passion, and a man being scourged by a woman. If we read the picture from left to right we might guess that worldly beauty, *Pulchritudo*, is transformed by the chastisement of *Amor* into *Voluptas*, the glorious and 'naked truth', an image of idealized and passionate love.

**Illustration to Nizami's *Khamsa* by
Sultan-Muhammad (?)
1539–43**
Gouache (?) on paper
36.8 x 25.4 cm

An elderly woman is seen accosting a twelfth-century Seljuk Sultan named Sanjar. The crone complains that she has been robbed by one of his soldiers, but he is dismissive, telling her that he is on his way to bring the entire world to order. She replies that his efforts will fail if he cannot control his own men. The message is not lost on his entourage and the landscape itself seems to be listening, for every rock is imbued with life, some composed of as many as three animal or human forms. The mood of the miniature suggests refinement and luxury, qualities echoed in the exquisite craftsmanship that shaped the entire book. This well-worn manuscript presently contains fourteen of the original miniatures and they seem to be the work of a number of artists belonging to the court. Like so many Persian manuscripts it was intended to appeal to the senses as well as the imagination. Such books were made as diversions for the rich and were composed of the finest parchment and painted with the rarest of colours. In the present picture the Sultan's court is represented as civilized and benign. The landscape, despite its animistic qualities, is paradisal (the word 'paradise' seems to derive from an ancient Persian word for park) – the very ground is gilded as if we were invited to share in some world of heavenly dreams.

Benvenuto Cellini (1500–71)
The Salt-Cellar of Francis I, _c._ 1540
Gold, enamel and ivory
Ht 26 cm

Few works of art can have been as well documented as this, for Cellini described its making in his interesting, if rather boastful, autobiography. There we learn how the French king Francis I ordered that Cellini should be given a thousand gold crowns from which to make the salt-cellar and how he was subsequently forced to defend himself (and the money) in single-handed combat with four armed men. According to Cellini the work represents the entwining of land and sea. Neptune, the god of the sea, is shown in a nautical 'triumphal car' pulled by four sea-horses. The alternately bent and straightened legs of the figures are intended to typify the mountains and flat places of the earth. The work is characteristic of a style known as Mannerism, much in vogue between 1520 and 1590, in which a certain extravagance and self-conscious attention to presentation is not simply favoured, but rejoiced in. Having narrowly escaped being melted down, the salt-cellar came into the possession of Charles IX of France who presented it to Archduke Ferdinand of Austria on the occasion of the latter's wedding.

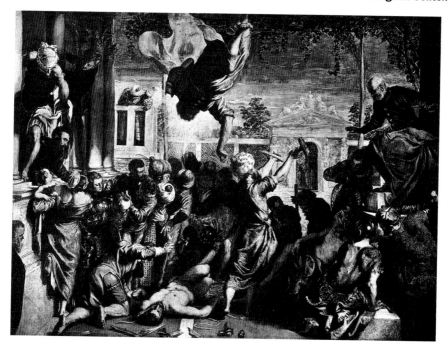

Tintoretto (1518–94)
Miracle of St Mark Freeing the Slave, **1548**
Oil on canvas
145 x 208 cm

The Venetian Republic contained a number of *scuole* – small quasi-independent organizations which took care of their members' interests irrespective of their social status. These were civil institutions, but they had close religious ties and often possessed some relic of their patron saint. The present picture was commissioned by one of these *scuole*, the Scuola Grande di S. Marco, and the subject was therefore relevant to that institution and to Venice herself. It illustrates the miraculous intervention of St Mark to prevent the torture of a slave, whose only crime seems to have been that he disobeyed his master's instructions by setting out to reverence a relic of St Mark! It is tempting to see the extraordinary vitality of the composition as a reflection of the magnanimity and confidence of contemporary Venice. However, the highly theatrical painting seems so much ahead of its time that it appears to anticipate the Baroque, which is essentially a seventeenth-century style. To achieve his effects Tintoretto has borrowed some of his figures from Michelangelo, whose works he could only have known from models or engravings, as he himself rarely ventured outside the city.

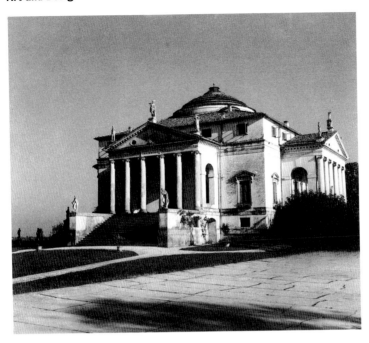

Andrea Palladio (1508–80)
Villa Rotonda, Vicenza, begun *c.* 1550

Palladio was a devoted student of Classical building in general and of the writer and architect Vitruvius in particular. He also learned a great deal from his Renaissance predecessors and, like them, was especially keen to revive the Classical taste for centrally planned structures (buildings whose ground plan is essentially symmetrical on both axes and which many Renaissance architects thought of as paradigms of perfection). The Romans had once set up extensive farming communities around Vicenza and now, after centuries of neglect, the time was right to recall that more productive and settled time. The political stability of the Veneto was such that castles were no longer called for and it was possible to rule and farm the land from country houses. The stage was set for the introduction of what the ancients had called the *villa suburbana* – the suburban villa. These villas were designed to integrate with the landscape and this effect is obtained in the Villa Rotonda by the four outward-facing hexastyle porticos that command a wide panorama. However, Palladio seems to have been incorrect in believing that the Romans gave their houses such grand temple-like entrances. Despite this, the Villa Rotonda and similar structures were to become the model wherever patricians sought to create the appearance of a well-run agrarian economy.

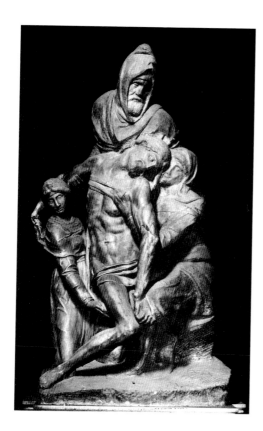

Michelangelo (1475–1564)
Pietà, **late 1550s**
Marble
Ht 226 cm

Over the course of a long life Michelangelo had seen profound and disturbing changes, especially in the sphere of religion. Oppressed by old age and infirmity he began to take an increasingly pessimistic view of his own life and work, and also of the ability of men and women to improve their lot by their own efforts. He began to associate with a group of intellectuals who advocated radical changes in the Church, reforms that were Protestant in all but name. Emphasis was placed on the Pauline doctrine of salvation by faith alone. Something of the artist's growing sense of resignation can be detected in his work, certainly from the 1530s, and the mood reaches a climax in his last sonnets and in two unfinished carvings showing Christ taken down from the Cross. Here his lifeless body is supported pitiably by his mother, Mary Magdalene and Joseph of Arimathea. The latter's face is clearly a self-portrait and emphasizes the artist's identification with bereavement and death. No doubt Michelangelo also hoped to participate in Christ's resurrection, but his poetry reveals a fear that his life has been wasted and that he will not escape what he thought of as 'the second death'.

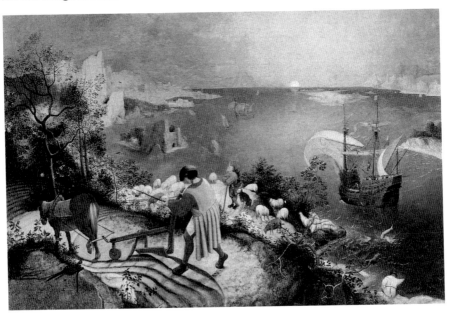

Pieter Bruegel the Elder (*fl.* 1551–d. 1569)
Landscape with the Fall of Icarus, c. **1558**
Oil on panel transferred to canvas
73.5 x 112 cm

Bruegel was trained under two Flemish artists who were among a growing generation of 'Romanizers'. However, despite making a journey to Italy at the age of twenty-seven, he seems to have been more interested in the landscapes and the people that he saw on the way than in Italian art. He lived in what has been called 'the century of beggars' and he must have known much about the injustice and religious persecution that spawned many Protestant malcontents. *The Landscape with the Fall of Icarus* may say quite a lot about his contempt for the cultured aristocrats who gave themselves airs. The story of Icarus's abortive flight to the sun would have been well known to the intelligentsia of his day. Bruegel, one feels, is on the side of the ploughman whose main concern is to guide his plough while treading the newly turned spit of earth with his sizeable boot. Of Icarus's well-merited descent we see but one naked (and no doubt highly Classical) leg waving helplessly from the bay in the bottom right-hand corner. We seem to be the only observers of this non-event!

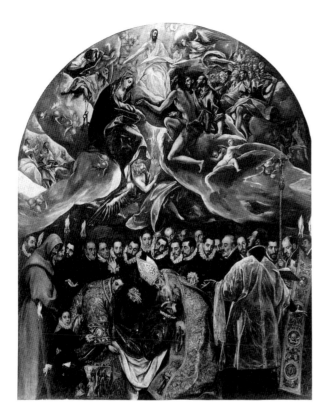

El Greco (1541–1614)
The Burial of Count Orgaz,
1586
Oil on canvas
460 x 360 cm

Count Orgaz died in the fourteenth century, leaving a will requesting burial in S. Tomé. Following a dispute about related payments the parish priest won a civil action against the Count's descendants. Disgusted by the meanness of these unworthy heirs and triumphant in his success at law, he asked El Greco to paint the events that were alleged to have accompanied the Count's interment. It seems that SS Stephen and Augustine had descended from heaven to lay the Count to rest with their own hands. They were showing their gratitude for a gift that the Count had made to the Augustinian order, enabling them to build a church dedicated to St Stephen. The upper section of the picture shows John the Baptist offering the Count's soul (in the form of a homunculus) to Jesus, who is seen with Mary enthroned in heaven. According to the legend, there were five hundred witnesses to this event and El Greco has taken this opportunity to include people whom he knew, including his erstwhile patron, Philip II. The painter's wholehearted and passionate rendering of the scene throws light on the convictions and emotions that fired Catholic Spain in the late sixteenth century.

Caravaggio
(1571–1610)
*The Calling of St
Matthew*, 1592–95
Oil on canvas
315 x 315 cm

The response of the Catholic Church to the growth of Protestantism took the form of a movement now known as the Counter-Reformation. Its characteristic expression in art is the Baroque. The style brought together a passionate interest in naturalism with an equally compelling belief in the power of dramatic presentation. It was a theatrical art, which sought to convince those tempted to change their faith that the Roman Church was and would remain the only custodian of religious truth. If Protestantism seemed gloomy, Catholicism had no alternative but to assert its fundamental optimism. So Caravaggio, one of the most important figures in the Roman Baroque, presents us with a remarkable stage effect, in truth far in advance of anything that one could have expected to see in the contemporary theatre. Christ's entry into the house of Matthew, the money-changer, could have found no more dramatic expression, and the two well-dressed young bucks anchor the picture to the reality of the sixteenth century. In all this, Caravaggio seemed to go too far and too fast for his contemporaries and his work was slow to achieve the enormous influence that came later.

Inigo Jones (1573–1652)
The Banqueting House, London, 1619–22

Jones was a contemporary of John Donne and Ben Jonson and was only nine years younger than Shakespeare. He may have visited Italy some time before 1603 and came to prominence as a stage-designer, introducing the English court to the masques characteristic of the Italian Baroque. A further visit to Italy in 1613, this time with the statesman and connoisseur, the Earl of Arundel, was devoted to the study of architecture, especially that of Rome and of the Venetian architect, Andrea Palladio. Jones was thus able to bring to England a vision of Classical building that contrasted with that strange if charming mixture of Renaissance and Gothic known as the Tudor style. The dependence of the Banqueting House on Palladio's ideas is seen clearly in Jones's preliminary drawings. While the linking of the horizontal and vertical features seen in the finished building in Whitehall is distinctly reminiscent of Palladio, the work is anything but a slavish copy. Some observers have seen in it a staidness that they claim to be typically English. Jones's buildings were a major factor affecting the second wave of Palladianism which dominated English building in the early eighteenth century.

*The Elephant Girdbāz Hit by a Cannonball
at Bhojpur*
Illustration by Dharmdās to the *Akbarnāmeh*,
1603
Gouache (?) on paper

Akbar, third in the line of great Moghul Emperors, was a man of action and a distinguished patron of the arts. His lineage was part-Turkish and part-Persian, though the Mongol, Jenghis Khan, was a distant ancestor. The art of northern India had once been exclusively religious, but Akbar, although sympathetic to the cultural background of those he conquered and capable of discussing religion with visiting Jesuits, encouraged an art that was essentially secular. The *Akbarnāmeh* tells of his campaigns and those of his father. In the present miniature we see an incident that occurred in a foray against the Afghans. A detachment of troops had been sent to cross the Ganges on a pontoon of boats. The Afghans attempted to smash the bridgehead with one of their war elephants, but the Moghul camp saved the day by disabling the poor creature with a well-aimed cannonball. The entire scene, including the general mayhem that breaks out among the astonished Afghans, seems to have delighted artist and patron alike.

Ching-te Chen vase
Mid- to late seventeenth century
Porcelain
Ht 24.1 cm

China's finest artistic achievement is usually associated with the porcelain that its potters invented in the ninth century. That development led to many centuries of virtually unbroken production at the vast complex of kilns at Ching-te Chen in the southern province of Kiangsi. During the reign of the Emperor K'ang Hsi there were increased exchanges between China and the outside world and a certain freedom and individuality crept into both painting and ceramics. The work at Ching-te Chen was furthered by the importation of Persian cobalt, which led to the manufacture of quantities of blue and white ware, much of it decorated in underglaze painting. The present vase imitates the form of a European glass bottle, but the freely applied brushwork draws on traditions that recall the practice of Ch'an Buddhist painting in China stretching back to the sixth century AD. This approach, known as Zen in Japan, involves the belief that through special training one can obtain moments of sudden enlightenment. Painters of this persuasion, whether working on silk or pottery, express their belief by the 'free' way in which they handle their medium.

Peter Paul Rubens (1577–1640)
Landscape with Château de Steen, c. 1636
Oil on wood
131.2 x 229.2 cm

Despite religious wars and persecutions Rubens managed to travel widely, to acquire a knowledge of Classical antiquity and to establish himself as a diplomat at some of the most important courts in Europe. His letters reveal a man of wide learning, immense industry and financial astuteness. Having lost his first wife, he remarried and lived his last five years in retirement at the moated and turreted Château de Steen. The wide sweep of the landscape offers a vision of a world at peace, seen through the eyes of a man with a sensitive and bounteous nature. It is what one might expect from a painter who had spent so much of his life in the service of diplomacy – the vision of a world that is accessible and at peace. It is a dream world that Rubens would have known from reading Virgil, for here a gentleman could live at one with nature and here too find consolation far from the cares of the city. It is an attitude to landscape that was to become immensely influential in Britain in the century that followed.

Nicolas Poussin (1594–1665)
Bacchanal before a Term of Pan, mid- to late 1630s
Oil on canvas
99.7 x 142.5 cm

France had been the first nation in Europe to assimilate something of the spirit associated with the Italian Renaissance, and by the time of Louis XIV it had a Minister responsible for organizing artistic production. Sadly, most French painters, yearning for the true source of their inspiration, left for Rome. Poussin, however, kept in touch with Paris, where his works were sold to the nobility. There their meaning and structure were hotly debated by connoisseurs, and the foundations were thus laid for Academicism, a movement which was to spread across Europe with profound if debatable consequences. In fact, Poussin himself became Superintendent of the French Academy in 1642, though he soon left for Italy, where he seemed to be more at home meditating amongst the Roman ruins. There he felt drawn to devise compositions that aimed at a kind of internal perfection and recalled a lost Classical Golden Age. One might feel that here Poussin came near to the spirit that animates the Parthenon frieze.

Rembrandt (1606–69)
Christ Preaching, c. **1652**
Etching
16 x 20 cm

Rembrandt came under the influence of a succession of teachers and patrons, some of whom saw him as the Dutch answer to Rubens. He was influenced by the work of Caravaggio and matched the Baroque spirit of his painting with the flamboyance of his lifestyle. After a number of professional misfortunes and personal tragedies he seemed to undergo a change in character. Although born of a Catholic mother and brought up in Catholic Leyden, his father was a Calvinist and Rembrandt seemed to turn more towards that faith as he grew older. Engraving had been practised since the fifteenth century, but it was Rembrandt who gave a sense of immediacy to both drypoint and etching, something that has been the envy of engravers ever since. The present print shows his new-found interest in shaping a distinctly Protestant iconography. The figures seem to be studies of the Amsterdam Jews among whom he lived. Their expressions and body language speak of introversion. Here we may think of the Protestant doctrine of justification by faith alone and sense something of the painter's increasing sobriety in the face of loneliness and advancing age.

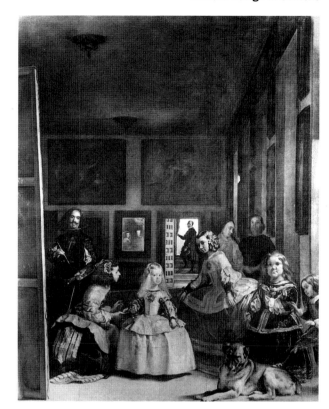

Velázquez (1599–1660)
Las Meninas, **1656**
Oil on canvas
318 x 276 cm

At the remarkably early age of twenty-four Velázquez was appointed painter to Philip IV and became an important figure at the palace. This gave him the chance to become familiar with paintings in the royal collection and to meet influential people. One of these was Rubens, who visited in 1628 and advised the King to allow Velázquez to study in Italy. Velázquez first went in 1629; a second visit to that country, this time to buy paintings and sculpture for the court, was undertaken in 1649. Association with the famous and high-born was taken in the painter's stride and his many portraits of the nobility show a relaxed and sympathetic insight into character. His ease is seen especially in this major work from his last years. The royal Infanta is shown with her maids of honour. The Queen's chamberlain stands watching from a distant doorway, while the King and Queen, who command the attention of the entire group, are seen reflected in a mirror. We see Velázquez standing before his massive canvas and on his chest there is the cross of the Order of Santiago. As the King did not bestow this prestigious favour on the painter until some three years after the picture was finished, it seems that this detail may have been added by another hand, perhaps at the King's command.

Jacob van Ruisdael (1628/9–82)
Extensive Landscape with a Ruined Castle, late 1660s
Oil on canvas
109 x 146 cm

The Dutch obtained their independence in 1579 and gradually won an awareness of nationhood. Attempts to describe the Dutch usually fall short of the truth and rest on generalizations. They are characterized as a stolid people and their middle-class and workaday approach to life is said to rest on the fact that so many of their number embraced Calvinism. The country's exposure to the sea, the flatness of the countryside and dependence on the vagaries of the weather may also have played some part in shaping a down-to-earth people. It is said that the Dutch lack imagination, but when applied to their art this assertion would have to be qualified to the point where it would lose any pejorative overtones. It is true that the Dutch saw their art as a trade that could be passed on in families. Thus, Jacob van Ruisdael's father was a painter and so was his cousin. Very far from unimaginative, this landscape, like so many of the painter's works, seems to brood. Some have seen change and decay lurking not only in the ruin on the right, but also in the melancholy areas of woodland and in the feeling of passing time engendered by the rolling clouds.

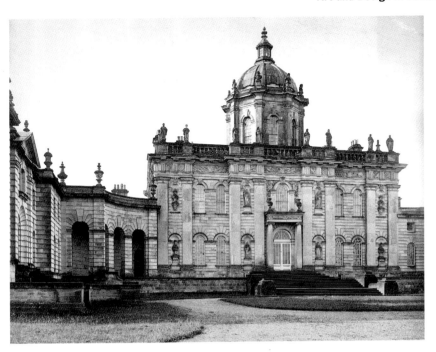

Sir John Vanbrugh (1664–1726)
Castle Howard, North Yorkshire, 1699–1712

England's ties with seventeenth-century Europe were complex and are reflected in the architecture of the latter half of the period. The country's acceptance of the full-blown continental Baroque had always been half-hearted and as the century progressed that resistance deepened and a specifically English form of Renaissance architecture evolved. With the advent of William III, England led the world in commercial power, and a new wealthy middle class, together with the already well-established aristocracy, sought homes to express their grand and cultured lifestyles. Two types of building were favoured, those whose plan was a simple rectangle and those with a more ambitious arrangement involving a central block with symmetrical corridors leading to wings containing a variety of ancillary apartments and services. Castle Howard is one of the best known of this latter type. Its various parts are clearly distinguished, yet each is related to the whole in such a way as to suggest vitality and movement, an aesthetic principle dear to the Baroque builders. The influence of the more reserved English Palladianism is nonetheless pervasive, most obviously in the giant Order that articulates the central block.

J.J. Kändler (1706–75)
Columbine and Brighella,
mid-eighteenth century
Porcelain
Ht 19.4 cm

Chinese porcelain became known in Europe in the fifteenth century, inspiring attempts to find the secret of its composition. Two German alchemists were the first to succeed, using a process involving the firing of fusible and non-fusible silicates of alumina at high temperature. The first Western porcelain was made at the Albrechtsberg at Meissen and after some experimentation it reached its finest expression under the modeller Johann Kändler. Reluctant to meet the King's desire for colossal figures, he turned to the production of a variety of tableware – plates, tureens, candelabra, etc. This switch in subject matter reflects a certain restless reaction to what was then seen as the pomposity of the Baroque. The new style became known, originally with disapproval, as the Rococo. The wanton curves and splendid enamelling led to the production of highly imaginative figure subjects. The characters here are taken from the Italian *Commedia dell'Arte.* Brighella was somewhere between a pimp and a bandit, whose task it was to arrange affairs of the heart; Columbine was simply a giddy flirt. The enactment and depiction of such stories were popular diversions with the aristocracy of Europe at this time.

Jacques Germain Soufflot
(1713 – 80)
Ste Geneviève (now the
Panthéon), Paris,
1757– 92

Attacks on the Rococo style were made increasingly from the middle of the eighteenth century when theorists began to demand a return to what they called the 'rational' and the 'ideal'. They admired Greek and Roman building, but only because those works expressed purity of form. Laugier, the most influential critic of the time, praised the rustic cabin for this very quality, and thought Soufflot's Ste Geneviève (called the Panthéon since the Revolution) 'the first example of perfect architecture'. This claim might seem strange today, for clearly Soufflot, while placing much emphasis on the simple post and lintel system, can hardly be said to have created anything as primitive as a 'cabin'. However, a comparison with any Renaissance building will show that Soufflot's reverence for the ancients was of a different kind from that once held by Palladio, for example. Here at the Panthéon there is no hint of Alberti's slavish and even mystical approach to the Classical builders. There are no pilasters and little in the way of pedestals. Where domes have been used it is because they were seen as 'natural' shapes and they are supported by the simplest of ribs – an elegant and light device that Soufflot was content to borrow from the Gothic repertoire.

Robert Adam (1728–92)
The Music Room, Home House, London, 1772, restored 1926

Elizabeth, Countess of Home, was seventy when she commissioned the building of what is now 20 Portman Square. She had inherited a fortune made in Jamaica and, now twice widowed, planned a venue where she could entertain her patrician friends, among them the Duke and Duchess of Cumberland, brother and sister-in-law to King George III. This was during the 'Age of Sensibility' and Robert Adam was the ideal architect to accomplish the work. In 1926 Samuel Courtauld found the present room in a state of disrepair, but, with the aid of Adam's original drawings, restored it to something like its former glory. Concerts had once been given here, when candlelight would have been reflected in the elegant mirrors and from the gilded details on walls and ceiling. Low reliefs and paintings made reference to the muses and to Classical stories associated with music and musicians. Like so many of his predecessors, Adam made the Grand Tour, but unlike them his interests extended to Roman domestic architecture and above all to the decoration and fittings that he associated with it. Images of the ruins of Herculaneum had been published during Adam's stay in Italy and these studies had doubled his interest in the day-to-day life of wealthy patricians in the ancient world.

**Sir Joshua Reynolds
(1723–92)**
Self-Portrait, **1773**
Oil on canvas
127 x 101.6 cm

Reynolds's authority in matters of style and taste was extremely influential. It stemmed from his Classical education, his three years of study in Rome and his ability to mix easily with the nobility. As President of the newly founded Royal Academy he gave a series of 'Discourses' in which he displayed a prodigious knowledge of the masters and laid down firm rules for his students to follow. He taught that 'history painting' was the highest form of art and that this could only be achieved by the adoption of a 'grand' style. This, though based on the study of nature, required the discovery and application of 'general laws', a theory that had been advanced by Renaissance Neo-Platonists. Reynolds held firmly to these ideas at a time when England was experiencing the first stirrings of a Romantic rebellion, a movement entirely at odds with ideas about general laws. The strange thing is that Reynolds had only meagre success in 'history painting' and his undoubted skill in portraiture owed a great deal to Rembrandt and to the Venetians, none of whom figured in his pantheon of the great.

Jacques-Louis David (1748–1825)
Oath of the Horatii, **1784–85**
Oil on canvas
330 x 427 cm

David's painting, though inspired by a story from Classical literature, does not follow any known version. We are shown the moment when three sons swear before their father to fight to the death for Rome. The mourning women, with a widow and two children beyond, belong to a later stage in the written narrative. It seems that in the original story the only survivor of a conflict involving six champions returned to Rome to find that his sister was mourning for one of those he had helped to kill. Apparently this left him with no alternative but to slay her also. David showed his contemporaries a moment that encapsulates the kind of tragedy that ancient authors thought inseparable from life itself. The message was that duty and destiny stood above personal hardship and that freedom and justice always demanded sacrifice and sometimes violence, even if it involved one's own kin. One may ask what part David played in precipitating the awful events that broke upon France less than eight years later. It is certainly a fact that David was involved in the Revolution and became in effect its artistic dictator.

Republican virtues had been extolled in France some time before the Revolution. Thus the Directoire aesthetic was a simplified version of the style that had flourished under Louis XVI. It took its name from the period between November 1795 and November 1799 when five 'directors' were appointed to control the political tensions and potential chaos that followed the events of 1791. The style, particularly associated with printed cottons, faïence ware, furniture and wallpaper, was self-consciously restrained and based where possible on Roman models. Such republican symbols as the cap of liberty and the fasces became pervasive. The present stool recalls Roman fold-stools (though here the geometry is fixed), especially in its lion's-head finials and in its paw-shaped feet. Such stools were well known in the Middle Ages too, and a somewhat more ornamental version of one was associated with the ancient Frankish king, Dagobert. The austerity of the work may have been partly due to the impoverished state of the French nation at this time, which prevented craftsmen from using costly imports and, above all, the splendid gold mounts typical of earlier styles.

X-stool in the Directoire style
c. **1795–99**

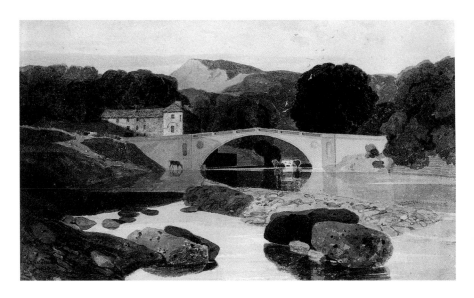

John Sell Cotman (1782–1842)
Greta Bridge, 1810
Watercolour on paper
30.2 x 50.2 cm

In the first half of the eighteenth century many artists supplemented their income by becoming drawing masters to the gentry and sometimes to their children. It was in this way that Cotman came to visit Rokeby Hall in Yorkshire. The owner, John Morritt, was a Classical scholar and, like so many of the wealthy of his generation, he had made the Grand Tour. Of his own estate he wrote to Sir Walter Scott: 'The scenery of the rivers deserves to become classic ground.' In fact, the whole area had Roman associations, for it was once the site of a Roman military encampment. Cotman seems to have risen to the occasion, for his 'pattern-making' style, worked out when he belonged to a London sketching society, has much of the formality, dignity and simplicity that one associates with the Classical past. Cotman belonged to an ever-growing body of artists working almost exclusively in watercolour, a medium that was especially well suited to those artists who became the travelling companions of cultured sightseers.

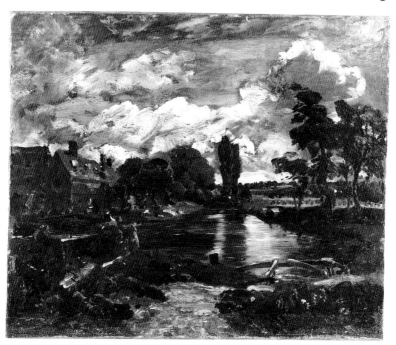

John Constable (1776–1837)
Flatford Mill from a Lock on the Stour, c. 1811
Oil on canvas
25 x 30 cm

Constable was brought up at East Bergholt, close to Flatford and Dedham, where his father owned mills. After some restless soul-searching, he studied at the Royal Academy schools and tried to adapt himself to the British landscape tradition, which was much associated with the faithful representation of local topography. At thirty-five he broke out from what he saw as limiting and narrow expectations, committing himself to becoming, in his own words, 'a natural painter'. The oil sketches that he made during the next five years were taken directly from nature, and in them he sought to capture the freshness, movement and changing light that he associated with the landscape of his 'careless boyhood'. This movement of light and shade is what he thought of as 'natural chiaroscuro', as opposed to the artificial drama of the Baroque tradition. For all the passion in these sketches, Constable's approach has been compared to that of the natural scientists of his day. His sketches, sometimes associated with notes on the weather, were the 'experiments' that formed the basis for the larger canvases that he sent to the Royal Academy Summer Exhibitions in succeeding years.

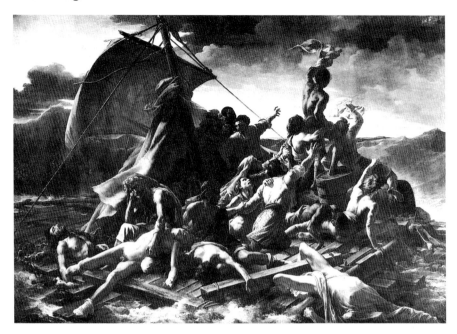

Théodore Géricault (1791–1824)
The Raft of the 'Medusa', **1819**
Oil on canvas
491 x 716 cm

Romanticism may in part be traced back to Jean-Jacques Rousseau, whose 'Liberty, Equality and Fraternity' became the watchwords of the Revolution. He appealed to natural law, exalting the goodness of man over the corrupting influences of institutions. Géricault was responding to similar sentiments when he based his *Raft of the 'Medusa'* on an event of 1816. The *Medusa*, manned by sailors from the corrupt and incompetent royalist navy, had run aground on its way to Senegal. The lifeboats were inadequate, so a raft was made to carry the 150 people who were otherwise uncatered for. These were set adrift and during the thirteen days of their ordeal they quarrelled and finally fell to cannibalism. The event was seen by the Bonapartists as a national scandal. However, despite a great effort to get his facts right, Géricault's real subject seems to have had deeper roots. A few months after the *Medusa* incident he had been studying in the Sistine Chapel. Géricault's well-fed 'survivors' may seem to owe more to some of the tortured souls in Michelangelo's *Last Judgment*, cast adrift in eternity, than they do to starving Frenchmen.

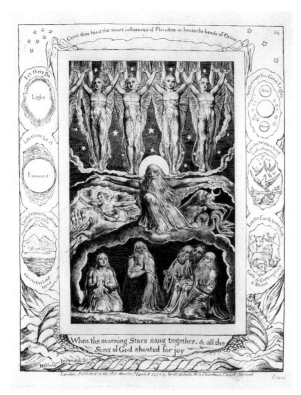

William Blake (1757–1827)
The Creation, from
*Illustrations of the Book of
Job*, 1825
Line engraving
19.3 x 15.1 cm

Blake was a writer, poet, artist and visionary. He sided with the aims of the revolutionaries in both France and America and found common cause with Thomas Paine, author of *The Rights of Man*, and with William Godwin, author of the *Enquiry concerning Political Justice*. He was commissioned to produce engravings for the Book of Job by his artist friend John Linnell, and the uncompromising theology of the text obviously appealed to him. This illustration is to chapter 38, which tells how God addressed the querulous Job from 'out of a whirlwind' demanding: 'Where wast thou when I laid the foundations of the earth? ... When the morning stars sang together and all the Sons of God shouted for joy?' Blake, though quite rational in the ordering of his day-to-day affairs, claimed to see images of past prophets and sages before his eyes and to draw them in their very presence. Naturally, he found himself at odds with the British establishment and especially with Sir Joshua Reynolds, whom he believed to be amongst those hired 'by the Satans for the depression of Art – a pretence of Art, to destroy Art'.

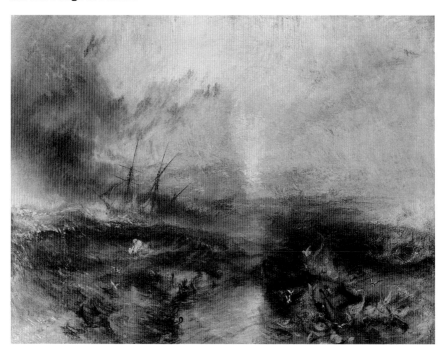

J.M.W. Turner (1775–1851)
Slavers Throwing Overboard the Dead and Dying – Typhoon Coming On, **1840**
Oil on canvas
 90 x 121.9 cm

Britain had made slavery illegal in 1811, but it was not abolished in her dominions until 1833. Turner may have read Thomas Clarkson's *History of the Abolition of the Slave Trade*, the second edition of which came out in the year before this picture was shown at the Royal Academy. There he could have read about a sea captain who dealt with an epidemic by throwing his cargo of slaves overboard, knowing that he could claim insurance on them if they were 'lost at sea'. Turner may also have been remembering a passage written by the poet James Thomson, describing a slave ship wrecked by a typhoon. In all this, the painter was responding not only to a particular incident, appalling though that was, but to a new apprehension of nature which had been defined by the British philosopher Edmund Burke. This mode of experience was known as the Sublime and had to do with the sharpening of awareness through the contemplation of things terrible or awe-inspiring. The vastness of the ocean and the energy of the storm may be thought a substantial part of Turner's 'real' subject. Such perceptions lie close to the heart of what has become known as Romanticism.

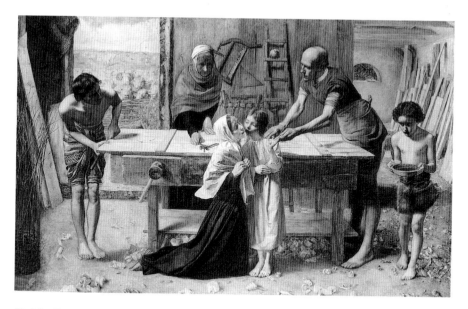

Sir John Everett Millais (1829–96)
Christ in the House of His Parents, 1849–50
Oil on canvas
86.4 x 137.9 cm

Beginning in the mid-nineteenth century, there were Europe-wide attempts to address the needs of 'the common man', both politically and in art and literature. One elite faction, adopting the name 'The Pre-Raphaelite Brotherhood', set itself the task of ridding art of all pretence – a fault it deemed to date from the time of Raphael. These artists wanted to make pictures for down-to-earth, honest folk rather than connoisseurs, and were unashamed of their interest in story-telling. Inspired too by natural history, they wanted to present pictorial encyclopaedias of the world's wonders. While essentially 'modern', they sought to restore what they understood of medieval values in religion, morality and craftsmanship. They condemned the methods of those artists whose appeal was to the aesthetics of either Romanticism or Classicism, and tried to emulate the working methods that they associated with artists of the fourteenth and fifteenth centuries. Much of their revolutionary zeal can be seen here in the finely worked details (notable especially in Joseph's arms and face, the painting of the wood shavings and the smoothly polished vice). The picture is also replete with a story-telling symbolism, as for example where the Christ child shows a bloody wound in his hand, a prefiguration of the manner of his death.

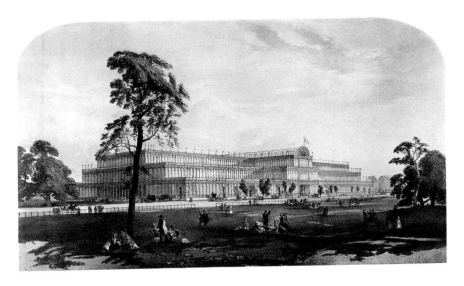

Sir Joseph Paxton (1801–65)
The Crystal Palace, 1850–51

Great Britain pioneered the Industrial Revolution and by the mid-nineteenth century was at the centre of a worldwide Empire. If one adds to this the fact that the Prince Consort was devoted to the promotion of art and industry, then it is not surprising that England should have hosted the first international fair of its kind – 'The Great Exhibition of the Works of Industry of All Nations'. The event was organized with considerable speed, and the plans for the main building were only sketched out eleven months before the opening. There had been an abortive attempt to establish a grand design, which encouraged Paxton to submit a revolutionary idea. His claim to expertise was that as a gardener to the Duke of Devonshire his inventive nature had been recognized and he had been entrusted with the design of some large greenhouses and (following another and not unrelated commission) some train sheds. For these buildings he had used iron and glass in a new system of roof construction and this is what he proposed for the exhibition's home. The components were constructed in various parts of the country and assembled on site in Hyde Park, providing the first example of prefabricated architecture. The building was taken apart after the exhibition and re-erected at Sydenham.

An undersprung step-piece barouche by Hallmarke and Aldebert
Shown in the Great Exhibition of 1851

Although the Great Exhibition was hailed as an enormous success, the aesthetic qualities of most of the products on display have been called abominable. The odd thing is that when it came to serious practical problems the Victorians were clearly prepared to allow their zeal for ornamentation to take second place to the dictates of pure engineering. This must have been particularly important in the design of carriages, for although J.L. McAdam had made great strides in the science of road building, the need to make speedy and comfortable journeys was increasing, if only as a spin-off from the development of the railways. Elliptic springs (seen here at front and rear) had been invented in 1804 and were used as 'cushions' between the relatively rigid coachwork and the axles. The upward curve of the body enabled the front axle substantial freedom to turn. Apart from the driver, the barouche was designed to take two couples seated face to face. If we glance at the illustration on p. 144 we will see that Courbet has just arrived outside Montpellier by 'diligence' (a 'coach of speed'). Given the state of the road, we can only wonder at his lofty composure!

Gustave Courbet (1819–77)
Bonjour, M. Courbet, 1854
Oil on canvas
129 x 149 cm

France was beset by political turmoil throughout the nineteenth century and this left its mark on all the arts. Courbet rejected the approach of the Romantics and the Neo-Classicists and styled himself a 'Realist'. He had a deep regard for many traditional masters, most notably for Giorgione and Velázquez, but as a Socialist he rejected any form of enslavement to the past and glorified what was present and knowable. These attitudes became central in French art, and with hindsight these paintings can be seen as the precursors of Impressionism. A collector in Montpellier asked Courbet to paint his portrait, suggesting that it should celebrate their meeting outside the town. Courbet has given his composition the kind of grandeur that earlier painters might have reserved for highly charged events – one may think, for example, of Velázquez's *The Surrender of Breda*. Just such a strange kind of exaltation of 'the ordinary' was indeed close to Courbet's heart, as it was to that of the poet Baudelaire. Much as *The Communist Manifesto* of 1848 had sought to set the working class free, so Courbet tried to liberate painting, stylistically and iconographically.

Claude Monet (1840–1926)
The Beach at Trouville, 1870
Oil on canvas
37.5 x 45.7 cm

Monet began his artistic career showing caricatures in the window of a shop owned by a painter who lived in Le Havre, Eugène Boudin. The latter took the seventeen-year-old Monet on painting expeditions and, according to the younger painter, 'with untiring kindness . . . undertook his artistic education'. Boudin insisted on painting directly from nature, claiming that it was vital to retain 'one's first impression, which is always the right one'. Twelve years later Monet was again on the Normandy coast, this time with his former mistress and model Camille, whom he married in June. He had been bought out of the army eight years earlier by an aunt and now, by virtue of his marriage, he escaped the military conscription that followed the outbreak of the Franco-Prussian War in July 1870. Fearing a second call to arms he lay low during that summer at the fashionable resort of Trouville. Here we see Camille with Mme Boudin taking the sea air as if war were far from their minds. It is clear that Eugène's lessons were now firmly part of Monet's working methods and, if proof were needed of this, grains of sand have been found embedded in the surface of the picture.

Paul Cézanne (1839–1906)
Mont Ste Victoire, c. 1886–88
Oil on canvas
66 x 89.8 cm

Cézanne, with his boyhood friend Émile Zola, became part of a general movement dedicated to the overthrow of what they saw as *petit bourgeois* values. Despite this, the painter was keen to obtain academic respectability and regularly submitted work to the Salon, where it was just as regularly rejected. He also cherished a profound regard for the traditional masters, whose work he studied with great diligence in the Louvre. He was particularly interested in Courbet, Delacroix, Poussin, Zurbarán and the sculptor Puget. With the end of the siege of Paris, Cézanne began to work with Pissarro and as a result started to take on the light tone values generally associated with the Impressionists. He was forty before all these diverse influences came together in a uniquely recognizable style. He and Zola had grown up not far from the slopes of Mont Ste Victoire and Cézanne's home remained close by. After a long and restless 'apprenticeship', it was as though he had at last found a spiritual home. The painter has interpreted the mountain in terms of the Idealism of Poussin and the Realism of Courbet, a daring union made by one who had already learned much from the Impressionists' attitudes to light and colour.

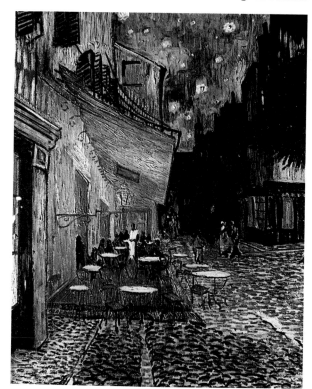

**Vincent van Gogh
(1853–90)**
Café Terrace at Night, **1888**
Oil on canvas
81 x 65.6 cm

As suggested on p. 54, Van Gogh had good reason to speak for the oppressed. Many see in this work, as in so many of his pictures, something of his battle with loneliness and his desire for spiritual comfort. This conflict is expressed in over six hundred letters to his brother, Theo. The letters also tell of a ceaseless fight with what could be thought of as purely artistic difficulties. He wrote, for instance: 'The problem of painting night scenes and effects on the spot and actually by night interests me enormously.' Similarly, there is often more in his letters about excitement than about despair. Of this work he wrote to another correspondent: 'This is a night painting without black, with only beautiful blue, violet or green, and in these surroundings the illuminated square takes on the colour of a pale sulphur yellow.' The picture seems to have been inspired by an account in *Bel-Ami* (1885), a novel by Guy de Maupassant, a copy of which can be seen in one of the artist's still-life paintings. However, it was partly an interest in the gaiety of Japanese prints that encouraged the artist to look for such subjects as this.

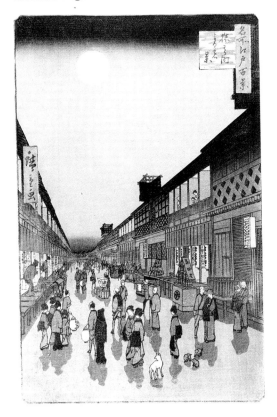

Hiroshige (1797–1858)
Saruwaka-cho [Night-life], from *One Hundred Views of Edo*, 1853–56
Colour woodblock print
35.9 x 22.9 cm

Neither the climate nor the geology of Japan favoured fresco, tempera or oils, the techniques central to Western painting. Japanese artists preferred to work in watercolour and on material that could be rolled up and stored for special occasions. Coupled with this limitation there is the fact that Japan deliberately sought to isolate herself from Western culture for well over two centuries. During this time there developed an artistic tradition known as *Ukiyo-e*, a word usually translated as 'pictures of the floating (or fleeting) world'. These were concerned with familiar, popular and sometimes frivolous day-to-day subjects. In the nineteenth century *Ukiyo-e* took on a new lease of life, now associated with the colour woodblock print – a process that imposed its own fascinating limitations. When Japan opened her doors to the West in 1853 there began an increasing interest in European picture-making skills, notably in the 'science' of *Uki-e* or 'perspective pictures'. Here Hiroshige, so much loved in the West for his sympathetic feeling for landscape, adopts a somewhat European attitude to a street in Japan's new capital.

The *Gates* were commissioned by the French
government as a doorway to a museum of
decorative art. However, they were never finished
and the museum was never built. Rodin's choice of
theme, from Dante's *Inferno* where Hell's Gate is
superscribed with the words 'All hope abandon, ye
who enter here', might be thought a pessimistic
beginning! However, it was a pessimism that
became increasingly part of the collective
consciousness in the last decades
of the century. The German
philosopher Schopenhauer had
laid the foundations for the
highly introspective Symbolist
movement and Rodin's view of
the world was coloured by it. At
thirty-four he visited Italy and was
powerfully influenced by the work
of Michelangelo. In fact, the
iconography of the *Gates* seems
to have something in common
with the Sistine Chapel's *Last
Judgment*, since in both the
figures seem to be involved in an
endlessly plummeting turmoil.
All the same, Rodin had a feeling
for modelling in clay that was
essentially 'modern'. Like the
Impressionists he could suggest
movement, but in his case
the emphasis seems to be
on the transience of life in
a much gloomier sense.

Auguste Rodin (1840–1917)
The Gates of Hell, 1880–1917
Bronze
680 x 400 x 85 cm

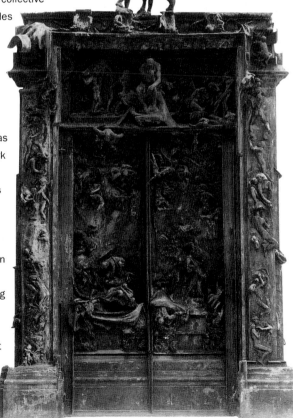

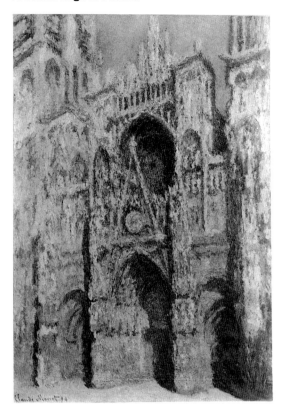

Claude Monet (1840–1926)
Rouen Cathedral, 1892–94
Oil on canvas
107 x 73 cm

Monet exhibited twenty views of Rouen Cathedral at a commercial gallery in 1895, all showing the façade under different lighting conditions. This relatively new direction contrasts with the approach he had adopted earlier in his career (see the illustration on p. 145). He had once been admired for his ability to capture a single moment in time, and for a kind of detachment that suggested his interest was virtually confined to the recording of tonal values and the accidents of light. The Rouen pictures, on the other hand, were conceived as a series, and seen together they are anything but detached in mood. Monet, who had once been described by Cézanne as 'only an eye', now seemed to be revelling in a kind of poetic 'dream'. If this is a fair assessment, then it ties in with much that had been happening in literature, music and painting in the last decades of the nineteenth century. Monet's *Cathedral* series can be linked to the Symbolist movement mentioned in connection with Rodin's *The Gates of Hell*. Here, however, there is no hint of the morbidity associated with that movement, for the mood seems simply mystical – a strange development for Monet, who claimed no interest in religion.

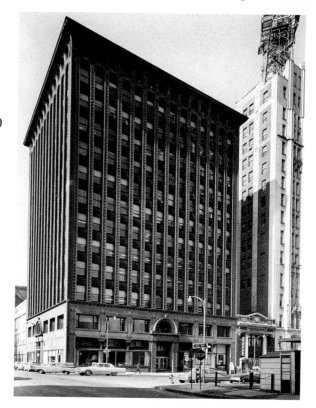

**Dankmar Adler (1844–1900)
and Louis Sullivan
(1856–1924)
Guaranty Building,
Buffalo, 1895**

Louis Sullivan's often-quoted maxim 'form follows function' was never intended to be a recipe for a mechanistic and utilitarian architecture. Like Nietzsche, Sullivan believed in an eternal 'life force' and wrote on these matters with enthusiasm. For much of his professional life he worked in collaboration with the engineer Dankmar Adler in Chicago, where the population density and the high land prices made tall buildings a necessity. Conventional architects had found that such buildings required proportionately massive and costly supporting masonry and that access to the upper floors was restricted to all but the exceptionally fit! These difficulties were overcome in Chicago by the use of rolled steel framework and the invention of the passenger lift. Although Sullivan had asked for a halt to the use of applied ornament so that architects might rejoice in what he called 'the comely nude', it is clear that in this Buffalo building the ornament was designed to appear (again in his own words) 'as though by the overworking of some beneficent agency, it had come forth from the very substance of the material'. In his attitude to aesthetics, Sullivan hoped to reconcile the gap between Eastern and Western cultures, a division that he claimed to see mirrored in the intellectualism of the Greeks and the emotionalism of the Gothic builders.

Charles Rennie Mackintosh (1868–1928)
120 Mains Street, Glasgow, 1900

Glasgow was a thriving centre for trade and industry at the turn of the century. More than this it was the home of a lively group of painters, the 'Glasgow Boys', whose sympathies and appeal were international. Mackintosh himself belonged to the 'Glasgow Four', a group of forward-looking architects now much associated with the Western movement known as Art Nouveau. Mackintosh's importance is seen in his refusal to pander to the ceaseless demand for revivalism in architecture. It is possible to find apparent echoes of various styles in his work – not least that of the Japanese – but his approach was markedly against imitation. Like Robert Adam, he saw the importance of structuring whole environments (see p. 132), and to this end he designed a wide range of furniture, light fittings, etc. The picture shows the drawing room of his own apartment, which belongs to what has been called his violet and silver period. The walls were painted in light grey and the woodwork in white. The daylight, filtered through muslin curtains, helped to give the room its air of unity and repose. Mackintosh abandoned architectural practice soon after 1916, partly due to lack of British patronage.

From the reverse these two caryatid figures can be seen to have highly complicated coiffures. The entire object serves a utilitarian purpose, that of protecting the fantastic hair styles for which the Luba are famous. Research has shown the popular belief that all African sculpture is essentially religious or totemic to be a wild generalization. It would seem that many tribes make objects for what might be called purely aesthetic purposes. While it may have been necessary to placate the spirit of the tree from which it came, the work is likely to have been carved directly, with no prior plan and with no religious or cult meaning. Interests in the relationship between mass and space, which are now familiar to most European artists, are matters that may have been much in the Luba artist's mind. At first valued for their anthropological significance, African carvings soon came to be appreciated for their formal qualities. Picasso, Modigliani and Derain all collected African sculpture. It was the apparently unrestrained qualities that appealed most, but despite the African artists' direct approach it now appears that most carvers worked to fairly strict general formulas.

Luba headrest
Wood
Ht 16.4 cm

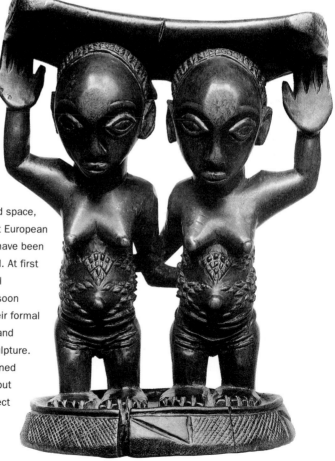

Henri Manguin (1874–1949)
The Gipsy in the Studio, **1906**
Oil on canvas
46.7 x 55 cm

In 1895 Manguin was among a group of artists working in the studio of the Symbolist, Gustave Moreau, when they were joined by the more experienced painter Henri Matisse. The group members, like many progressive thinkers, were becoming increasingly aware of the genius of Van Gogh, Gauguin and Cézanne and, following the example of these masters, were prepared to take exceptional risks with their art. This resulted in a sudden outburst, characterized by strong colour and vigorous drawing. So revolutionary was this onslaught on traditional values that the group were nicknamed *Les Fauves* (The Wild Beasts). They also drew inspiration from African sculpture, which one of their number, Vlaminck, claimed to have 'discovered' in 1904. Matisse actually collected primitive sculpture and summed up his own artistic aims as follows: 'What I am after, above all, is expression. ... I am unable to distinguish between the feeling I have for life and my way of expressing it.' This and so much else that the Fauves said and did can be tied to the influential contemporary philosophers Benedetto Croce and Henri Bergson, both of whom considered intuition the primary tool for the artist.

Walter Sickert (1860–1942)
Ennui, c. **1914**
Oil on canvas
152.4 x 112.4 cm

Sickert had come under the influence of both Whistler and Degas, who in turn had been subject to the Realist philosophy of Courbet (see p. 144). Sickert established a more or less continuous contact with French painting, working in Paris and Dieppe as well as in London. His debt to Degas is seen in the way that he learned to surprise his subject, often appearing to steal a glance at some person or persons when they might think themselves alone. He developed this interest in the context of the lower orders of society, picturing scenes in seedy boarding houses and revelling in the vulgarity of the music hall. He became a focal figure for a number of like-minded artists who were endeavouring to breathe new life into what they saw as the moribund art of Edwardian England. They called themselves the Camden Town Group. As with Degas, Sickert's compositions look deceptively casual. They are invariably constructed with great artifice and helped to establish a tradition in British painting that was imitated, if not actually built upon, by the London Group and by many individual painters.

Clarice Cliff (1899–1972)
Selection of pottery wares for Newport Pottery, c. 1930

Although some had anticipated the First World War, nobody imagined its true horror. The reaction that followed its end was profound and characterized by a new liberalism and even libertinism. However, the vigorous and iconoclastic quality of Cliff's pottery, like contemporary jazz, had its origins in the pre-war era. Her work can be seen as typical of Art Deco, a style that takes its name from 'L'Exposition Internationale des Arts Décoratifs et Industriels Modernes', held in Paris in 1925. The style's origins can be found in Art Nouveau and also in Cubism, Futurism and Constructivism. Its proponents took issue with purists like Le Corbusier, who saw art as solely concerned with the functional and 'necessary'. Cliff started at the bottom, becoming an apprentice in a Staffordshire pottery at the age of thirteen and going on to become a company art director. In this capacity she was to invite many notable artists to design the decoration of tableware – a venture that proved less than successful. Cliff took advantage of new marketing strategies to promote a whole range of tableware, such as 'Caprice' and 'Sunburst', under the appropriate general name of 'Bizarre'.

Henry Moore (1898 –1986)
Reclining Figure, **1936**
Elm wood
Length 106.7 cm

Moore began to make reclining figures around 1927–29 and came back to this theme on many occasions. He had been deeply impressed by the work of Brancusi and Picasso, seeing them not so much as pioneers but rather as men reasserting primal and instinctive attitudes towards art. On an early visit to Paris he saw an Aztec chacmool (see p. 158) in an exhibition and is known to have been deeply moved by it. Until 1940 Moore was especially committed to carving and to remaining true to his material, allowing the wood or stone some 'say' in each work's evolution. His principal concerns were with organic growth and with establishing parallels between figures and landscapes. Many observers have pointed out the womb-like structures in so many of his figures, supporting the notion that one of his main themes was the celebration of the archetypal earth mother. Others have commented on the mathematical nature of his works, seeing them as essays in topology. Moore's interest in Surrealism sometimes led him to create sinister images that suggest menacing and irrational fusions between different life-forms.

The ancient city of Tula, built in an arid and inhospitable country, was once a thriving community with three pyramids and a royal palace. The latter was guarded by images of prowling jaguars, coyotes, predatory eagles and even more intimidating hybrid beasts. In the palace itself, before the thrones of the ruling elite, there was an array of chacmools. These rain-god images seem to derive their form from the recumbent captives once placed before the stelae of the Mayan classical period. Chacmools have been associated with bloody sacrifice and they are usually carved with a dish-shaped hollow to receive human hearts. The violence of the culture seems to have been transmuted into objects that compel our attention and where the formal complexity indicates a powerful feeling for what Clive Bell might have called 'significant form'. Works of this kind, reaching as they seem to do into the depths of human consciousness, took on a special importance in the first decades of the twentieth century, when psychoanalysis was beginning to reveal the primitive contents of the human psyche.

Chacmool from in front of Pyramid B, Tula, Mexico
c. **1200**
Basalt

Henry Dreyfuss (1903 – 72)
'300' type desk set, 1937
For Bell Telephones

In 1876 Alexander Graham Bell demonstrated that the human voice could be transmitted electronically, conjuring up a vision of interpersonal communication over great distances. For this to become a reality, signals had to be amplified and switch gear invented that would make it possible to call just one subscriber out of many. One of the difficulties encountered initially was that mouthpiece microphones were apt to relay the sound emitted by the earpiece. Problems of this kind made it clear to engineers that the telephone had to be designed from the inside out. However, Dreyfuss understood that machines (of whatever kind) had to be adapted to people, rather than the other way round, and he was to set out his ideas in *Designing for People* (1955) and *The Measure of Man* (1961). In all this he was a proponent of the new sciences of ergonomics and anthropometry. Telephones that combined the transmitter and receiver in one piece had been among the many designs used since 1900, but the light, easy-to-clean and unobtrusive instruments that we have today owe much to Dreyfuss.

**Corradino D'Ascanio
(1891–1981)
Vespa motor scooter, 1947**

For those returning from active service and others released from duties on the 'home front', the end of the Second World War meant liberation. Taking its generic name from a child's toy and originally designed with women in mind, the scooter provided a means of getting about town. The spirit of camaraderie bred by the war had left behind a feeling of classlessness that was catered for by this novel system of transport, something quite alien to the enclosed, egocentric motor car. While the Vespa's engine parts were mostly of cast and machined metal, much of the bodywork and fairing was pressed into shape. The fact that shallow profiles are cheaper to produce than deep, angular ones played a part in the design. D'Ascanio, who had made his name designing helicopters, showed resourcefulness in making a virtue out of economic necessity, for the shapes that were the easiest to engineer also gave his scooter an air of modernity. Streamlining, originally developed to enhance aerodynamic properties, had already become identified with efficiency in general. Hence, the Vespa (and its slightly later rival, the Lambretta) appealed more to the 'educated eye' than to the enthusiast for speed. It was more than a decade before the Vespa became the plaything of teenage tearaways.

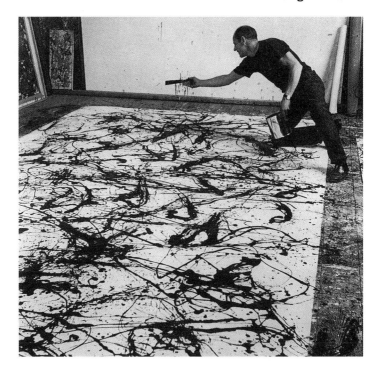

Jackson Pollock (1912–56)
Photographed at work by Rudolph Burckhardt

The emergence of depth psychology in the first decades of the twentieth century had a profound effect on most of the arts and all but coincided with the birth of Surrealism. That movement split, leaving two broad groups: those like Max Ernst who painted 'dream images' in a seemingly literal way; and those like André Masson, whose art took on something of the abandon associated with automatic writing. Pollock embraced that latter strand, but was also interested in the age-old archetypal themes that had appealed to artists for centuries. Not surprisingly, his interests centred on the psychology of Jung, who had shown the importance and universality of these themes in human development. In fact, some of Pollock's most important works were produced as part of his professional involvement with a Jungian analyst. Pollock claimed that he remained in control of the paint that he dripped and poured over his canvases, and saw his work as a kind of sacred ritual – not far removed from the attitudes and working methods of the Navajo 'sand painters' (see p. 163).

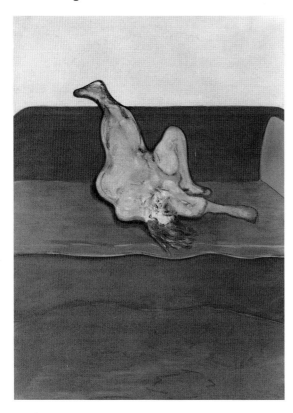

Francis Bacon (1909–92)
Reclining Woman, **1961**
Oil and collage on canvas
198.8 x 141.6 cm

It is tempting to see Bacon's picture as a cynical response to the long line of female nudes that invite idyllic, sensuous and perhaps sexual responses. One might also suppose that Bacon was giving substance to a growing emphasis found in twentieth-century philosophy, namely that associated with the existentialism of Jean-Paul Sartre, which asserted that man is fundamentally isolated and ultimately without hope. Apart from this development in pure thought, the century has seen two world wars, international terrorism and the threat of nuclear holocaust, and has witnessed a growing awareness of the omnipresence of disease and of man's capacity for carnage and bestiality. While Bacon's paintings go far beyond simply depicting 'the thousand natural shocks that flesh is heir to', his attitude to life was by no means negative. He spoke of a kind of exhilaration that he found in despair and saw the nervous system as made of 'optimistic stuff'. Despite the images of dissolution, close examination of Bacon's use of paint reveals a positive strength, the roots of which can be found in Expressionism.

Whirling Logs
Dry painting by shaman, Klah, 1965
Sand and charcoal
Dia. 175 cm

The art of the North American Indians goes back more than a thousand years, and yet these peoples have no term corresponding to our word 'art'. While the Navajo women are famous for weaving, the men have practised what is misleadingly known as 'sand painting'. Besides various coloured sands the Navajo use charcoal, corn meal, pollen and crushed petals, and their ritual pictograms are traced out in thin sprinklings on an area of smooth sand, sometimes extending up to seven metres in diameter. The paintings are destroyed when their healing or religious purpose is fulfilled, so what is known of the designs is mostly learned from copies made by outsiders, and, more recently, from photographs of shamans at work. The pictures are sometimes produced as part of a unified experience involving drama, recitation and music. The example shown is typical of one of three major designs where the outer border or 'guardian' has an opening towards the east. Carl Jung and his followers have shown that the myths of the Navajo are paralleled in very different cultures and that some of their designs resemble the mandalas that have a wide significance in Hindu art and mythology. Belief in universal and spiritual symbolism has had a powerful effect on many modern artists.

The fashion industry, like so many other aspects of consumerism, is seen by many as an important vehicle for artistic expression. It is as though the new world that the painter Piet Mondrian predicted in the 1930s has at last arrived and art has passed from the church and gallery to the streets and into every department of our lives. Designers such as Vivienne Westwood have captured the creative imagination of a generation. Much of this industry has traded increasingly on an ambivalence at the heart of modern culture. While on the one hand eminently practical, Dr Martens boots became associated with the aggressive anarchists of the 1970s who saw their role in life as that of putting fear (if not the actual boot) into those whom they saw as indifferent to their lot. The appeal of Dr Martens can be traced back to the seemingly narcissistic drape-conscious teddy boys of the 1950s, though the idea that men may legitimately dress for 'image' and perhaps for swagger has of course a much longer history. The present boots have come to be used by all sorts. While they have been worn by the famous, including Madonna and Elton John, they are still accessible to the only moderately well-off and are thought of as being as appropriate for a job interview as for a rave. They can be worn by the 'nice' and by the 'nasty'; this ambiguity is part of their appeal.

Dr Martens
1959

Richard Long (b. 1945)
A Line in California, 1982

This is one of a series of stone lines that Richard Long has made in various wild and barren places across the world. He sets out alone with backpack and camera, and as a performance artist his work is essentially one with his walking. When he experiences a landscape he allows it to suggest a response. The nature and distribution of rocks, stones or other features impose certain physical limitations on the artist – at one time he will scrape his boots along sandy soil, and at another, where the boulders are too heavy to lift, he may (as in California) choose to raise them into standing positions. Long's approach has interested the Cambridge theologian, Don Cupitt, an exponent of an awareness that he calls 'ecstatic immanence'. He writes of Richard Long as follows: 'So Long walks, but he's not going to any place in particular. He leaves traces, but they do not express any historically-conditioned human activity. They could have originated either from before history or after it. They may or may not endure. But they do have a sacred quality. And without wishing to over-interpret an important artist, I am suggesting that Long's journeys and his work may be read as symbolizing the continuing possibility of a dedicated and creative religious life, even today.'

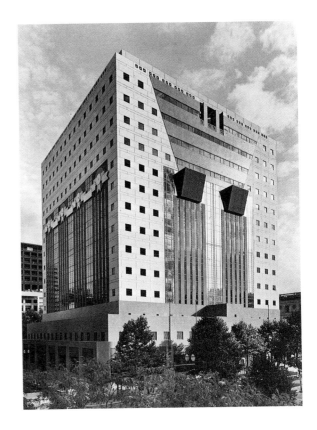

**Michael Graves (b. 1934)
Portland Building, Oregon,
1980–82**

Since 1980 there have been many architects prepared to question the purist theories and technological methods at the heart of Modernism. The claim has been made that the Modernists turned their backs on the expressive and human values so much admired in the building of former centuries. Some of these 'reactionaries' have become known as Postmodernists, and their answer has been to play down the structural aspect of their work and reintroduce 'style'. Denying that Modernism is a style, they have been obliged to ransack the repertoire of historical architecture, sometimes taking features from diverse sources and providing bizarre mixtures. Purists would call these excursions shameless parodies of the past, while defenders of this departure tend to rejoice in its outspokenness. Some Postmodernist work takes on the character of packaging, honestly proclaiming the commercial world that has spawned it. Thus, there are shopping malls that may seem like 'cathedrals' dedicated to consumerism. Graves's Portland Building typifies the new direction. Here the concrete sides of the building are painted as if they were enormous billboards, creating a 'brand image' that is compelling and elemental.

Damien Hirst (b. 1965)
Away From The Flock,
1994
Formaldehyde solution,
steel, glass and lamb
96 x 149 x 51 cm

There are some paradoxes that are beyond resolution. For example, there is the sheer inexplicability of existence and the fact that life can only be valued in the context of death. Hirst presents us with just such a contradiction. Lambs have been coupled with the idea of joyful innocence since the dawn of recorded history, but here we have one that is disturbingly real, dead and suspended in a mild poison. Those seeking parables might well see Hirst's work as a symbol or type of the *Agnus Dei* (the sacrificial lamb of Christianity), but the clinical directness of that frightful tank may cause us to stop in our pious tracks. How is it possible to live without bringing death to myriads of creatures? And if most of these are 'only microbes', where do we draw the line between these and such higher forms of life as the young lambs that Wordsworth described as bounding 'as to the tabor's sound'? Hirst is one of a number of modern artists (Conceptualists and their followers) who are trying to revitalize art by forcing us into the role of participants rather than that of mere spectators.

Willie Doherty (b. 1959)
The Only Good One Is a Dead One, 1994
Video installation shown at the Tate Gallery, London

Just who is wished dead is not made clear, neither is it implied. Doherty presents two eerie films made at night. Shot with a hand-held camera, the images are projected on adjacent walls, one sequence taken from the driver's seat in a moving car, the other from a fixed location: presumably a surveillance point. While the viewer tries to give undivided attention to one film, the other acts as a distraction. To complicate matters, a voice is heard, sometimes uttering the words of a potential victim, sometimes mouthing obscene threats. We are taken with Doherty to his homeland in Northern Ireland and forced to understand something of what is meant by urban warfare and sectarian violence. Here we are obliged to question the words that make it easy to keep this nightmare world at arm's length – such black and white words as 'cowardly terrorist' and 'innocent victim'. While the inspiration is local, the overtones are universal. We are presented with a growing awareness that none of us is free from unreasoned prejudice and that we are each subject to an endless internal dialogue, known in its most acute form as 'paranoia'.

Guidelines

- All works of art need to be considered in terms of their background or context

- Every culture and generation has its own ideas about the nature of artistic 'inspiration'

- Artists both shape and are shaped by their times

- Individual works of art may be interpreted in many different ways, using different kinds of knowledge – iconographic, cultural, political, economic, etc

9 The Essential Literature

As I stated at the outset, this book is not primarily intended for those specializing solely in art history at degree level. For them the appropriate books are often difficult to come by and they should consult their tutors and college librarians about their needs. They will also find Chapter 5, 'The Literature of Art History', of Marcia Pointon's *History of Art: A Students' Handbook* (1994) very valuable.

Most other students will be guided in their reading by the booklists published by their examiners. These are tailored to specific courses and the present guide makes no attempt to duplicate the advice given there. Unless the chief examiners are exceptionally diligent, some of the titles will be found to be out of print, a difficulty partially offset by the fact that there is usually a substantial overlap where coverage is concerned. Some of these lists will seem especially tough on those who have not established sound habits of reading, possibly owing to a dependence on video or CD-ROM learning programmes. However, some art history is already available in these forms and it is a trend that is likely to continue. Whether the approaching 'information highway' will extend or restrict one's understanding of the history of art is open to debate. Ease of access is one thing; taking the material 'on board' and knowing how to use it is quite another. For the time being at least, examination papers rely on the printed word, and it is disturbing to find that, through lack of familiarity with written English, some students fail to understand set questions. Here, then, we will confine ourselves to books.

Art books are notoriously expensive and, if you are not well-off, book-buying raises a major problem. The best solution is to make the most of your school, college, university or municipal library. However, there are books that you should have ready access to and some of these are fairly inexpensive. More will be said about these at the end of the chapter.

According to Browning's Andrea del Sarto, 'A man's reach should exceed his grasp.' The object of education is to extend our abilities, and to do this it is essential to come face to face with our limitations. There is a point, however, when recourse to dictionaries and encyclopaedias becomes so tiresome as to be self-defeating. It is up to each student to know where to strike the balance. Perhaps the most important thing is to find your own level in the literature.

It is painfully easy to 'read' without taking anything in. It happens when the material appears too demanding, and rather than admit the difficulty we read on in

a benighted attempt at self-deception. The best way to overcome this is to take notes. This is not at all the same as underlining passages in a book, a practice akin to vandalism which usually fails as an aid to concentration. It is quite surprising how stimulating it is to summarize, say, five or six sentences in one or two well-considered phrases. These notes will serve a dual purpose, that of focusing your attention while providing material for later revision.

Whether or not you are required to answer a general paper, it is important to have some knowledge of the wide range of art and to understand something of its place in human affairs. This background material might be divided into five main areas: aesthetics; iconography; the history of styles; the science of perception; and the political and sociological factors that govern the practice and understanding of art. How deeply you are prepared to go into these matters will depend to some extent on your intellectual background and, more especially, on the level at which you are working. The 'average' reader might find much of this material covered in the following: Sir Herbert Read's *The Meaning of Art* (1931), E.H. Gombrich's *The Story of Art* (1950; repr. 1995) and *Art and Illusion* (1960; repr. 1993), Elizabeth Gilmore Holt's *A Documentary History of Art* (1982) in two volumes, and John Berger's *Ways of Seeing* (1972). So far as iconography is concerned there can be no substitute for wide reading – a good general knowledge of the Old and New Testaments and of Classical mythology would be useful. Hall's *Dictionary of Subjects and Symbols in Art* (1979) and the *Encyclopaedia of Themes and Subjects in Painting* by Howard Daniel and John Berger (1971) would provide useful starting points for these studies.

Larger dictionaries and encyclopaedias pose another problem, but some of the bigger municipal libraries have the *Encyclopaedia of World Art* (New York, 1959–68), which will be found more than adequate by most. However, it would be good actually to own two kinds of smaller specialist art dictionary: a dictionary of art and artists and a dictionary of art terms. Probably the best are those published by Thames and Hudson: the dictionary of art and artists edited by Sir Herbert Read and revised by Nikos Stangos, and the dictionary of art terms edited by Edward Lucie-Smith (1994 and 1988 respectively). A rather more expensive volume that combines the functions of both these books is *The Oxford Companion to Art*, edited by Harold Osborne (1970).

If you are researching some fairly obscure subject and find that your local library is unable to answer your needs, you may find that the national interlibrary loan service can help. Failing this, there is a library of last resort, the National Art Library at the Victoria and Albert Museum. This has no borrowing facilities and there is no public access to the stacks. If you feel obliged to use this service you should write to the museum for an admissions policy leaflet. This may be obtained from Reader Registration, National Art Library, Victoria and Albert Museum, Cromwell Road, South Kensington, London SW7 2RL.

While it is important to take note of the bibliographies recommended by your examiners, there are sometimes reasons (whether related to availability or cost) for considering another approach. Many titles presently on the shelves of specialist bookshops will not be found on the lists prepared by your examiners. This may be because they are judged unsuitable at your level, but it is equally likely that they are new publications and have not had time to filter through the system. The worrying thing is that, by the time they do, they may be out of print! If you have any doubt about a book's usefulness, your tutor will be able to advise you. Another 'opportunistic' approach is to pay regular visits to your local lending library, where the stock on the shelves will be continually changing. Secondhand bookshops vary enormously in pricing and one can sometimes pick up what the trade calls 'a good working copy' of a book for a fraction of its original price.

There are two well-known series of art books that between them cover a very wide range. The first is that originally published by Penguin as The Pelican History of Art. Even the paperback volumes in the series are quite expensive. However, some of these books have been revised and reissued by Yale University Press at very reasonable prices. The second of the series mentioned is very competitively priced and is published by Thames and Hudson as the World of Art Library. The likelihood is that titles from both these series will already appear in your examiners' lists, but others may simply be too new for that.

Guidelines

- Booklists prepared by your examiners are useful, but they can also be out of date!

- Exploit new ways of accessing information, but don't neglect the more traditional methods and the skills they help you to develop

- Reading specialist art books can be difficult at first – begin by finding a level in the literature that suits *you*

- Make notes as an aid to concentration

- There are key standard works on a variety of background subjects which you should investigate

- Art books can be expensive – make the most of libraries

- A few dictionaries and encyclopaedias are indispensable

- Keep an eye on specialist and secondhand bookshops

Appendix I
Joint Degrees, Diplomas and Certificates

The history of art is combined with other subjects at many universities and colleges. In a few cases (such as Goldsmiths College, London) it is paired with fine art. One university offers as many as sixty possible combinations. The content of these courses is only touched on in the prospectuses and will be subject to change. It may be assumed that students will have to submit essays on a regular basis and will be subject to internally assessed written examinations. Several universities, colleges of higher education and most art colleges offer Foundation, BA fine art and Dip.HE courses where art history studies are mandatory. Here again, the content is rarely spelt out, largely because colleges see the historical and critical aspects as being so closely interrelated with practical work as to be unpredictable. The following is a typical course outline: 'All students on Foundation, Dip.HE and First Degree courses follow a programme in History of Art, Cultural, Critical and Contextual Studies. Courses will provide an introduction to the main European cultural tradition. All students produce a substantial piece of written work demonstrating their ability to conduct sustained research.' In some institutions, particularly those offering a more academic approach (directed towards art criticism and curatorship, etc), as much as forty per cent of course time is devoted to these studies. There are usually written papers at the end of the third year, and in the fourth year a substantial essay (of up to 10,000 words) is sometimes required.

BEd and BA(QTS) Courses
These teaching qualifications are offered by institutes and colleges, almost all of which are associated with universities. Some offer the opportunity to develop art and craft skills as part of a general qualification. Those working in this area are required to follow a specific course in the history of art. The development of art education is now inseparably linked with the history of European art in the nineteenth and twentieth centuries. Here, therefore, there is an overlap between the 'principles and practice' of art education and the history of art in general. Students are usually required to answer at least one question paper on their chosen area of study and to write essays.

BTEC Advanced GNVQ in Art and Design
This new work-related qualification offers a choice of routes into higher education and employment. The standard is equivalent to A-Level and also to the BTEC National Diploma in General Art and Design, which is shortly to be phased out. The course has a mandatory unit in 'Historical and Contextual References'. In this, candidates are obliged to 'investigate and

analyse historical and contemporary influences on the work of artists, designers and art movements, before relating them to their work.' There are two optional units where students are encouraged to extend their 'insight and appreciation of methods used by artists and designers ... and to investigate their own critical judgements of their techniques, and make their own appraisal of their work.' The first of these units is directed towards 'the two-dimensional visual language used by others' and the second to the 'three-dimensional visual language used by others'.

BTEC National and Higher National Diploma
These qualifications (the 'National' taking two years and the 'Higher National' four years) include diplomas in such subjects as graphic design and photography. They all involve studies in the history of art and design but the content is not indicated in the prospectuses.

Courses for Adults
Many universities offer short extramural courses in art history, sometimes in conjunction with the Workers' Educational Association (WEA). These courses may lead to a certificate or diploma and may also provide credit points that count towards some degrees. The range of topics studied is wide and there is sometimes an interesting bias towards local themes. Even if it were possible to list all the current options it would not prove very helpful, as topics change very frequently. The following have been chosen to give some idea of the diversity at the time of writing:

Approaches to Medieval Art and Architecture (Birmingham)
Art of Asia: An Introduction (Oxford)
Art under the Dukes of Burgundy (Birmingham)
The Clothes We Wear (Manchester)
Gardens and Landscape in Art (London)
Hinduism and the Hindu Temple (London)
Historic Interiors and their Furnishings (Manchester)
History of Western Portraiture (London)
Image Makers and Propagandists (Reading)
La Belle Époque: European Art and Design, 1880–1914 (Oxford)
Legacy of Greece and Rome: Two Thousand Years of Classical Architecture (Manchester)
Making Sense of Buildings (Manchester)
Palaces and Courts of the Renaissance (Oxford)
Ten Victorian Houses (Reading)
Whistler and the Modern Movement (London)
Women Artists (Oxford)

Appendix II
Advanced and Advanced Supplementary Level Courses

A- and A/S-Level history of art (and design) is offered as a subject in its own right by the following boards:

Associated Examining Board (AEB), Syllabus 0606

University of Cambridge Local Examinations Syndicate (CAMB), Syllabus 9311 and
 Module Bank option

University of London Examinations and Assessment Council (ULEAC), Syllabus 9029

Oxford and Cambridge Schools Examination Board (OX/CAM), A/S 8514

University of Oxford Delegacy of Local Examinations (OXFORD), Syllabus 9839

Every effort has been made to ensure that the following summary of requirements is correct at the time of going to press. However, candidates should check with their teacher and the appropriate syllabus before starting work.

Key to abbreviations used:

Des	=	Design included in examination title or syllabus
Dis	=	Word limit to dissertation/personal study
Mand	=	Mandatory or not
Mark	=	Percentage weighting
Mod.B	=	Module Bank
PQ	=	Picture question(s) mandatory
WP	=	Number of written papers + time(s) involved
*	=	Approval of subject must be sought from the board

	WP	Dis	PQ	Des
AEB	2 x 3 hrs	-	Yes	-
CAMB	2 x 3 hrs	3,500/4,000 *	Yes	Yes
CAMB (A/S)	1 x 3 hrs	2,000/3,000 *	-	-
ULEAC	2 x 3 hrs	5,000	Yes	Yes
OXFORD	2 x 3 hrs	3,000 *	Yes	-
OX/CAM	2 x 3 hrs	4,000 *	-	-
OX/CAM (A/S)	1 x 3 hrs	2,500 *	-	-

A- and A/S-Level practical art/craft syllabuses which include the history of art as a mandatory or optional component:

AEB, Syllabuses 0603 and 0605

CAMB, Syllabuses 9309, 9302, 9304, 9317, 9322 + Mod.B, A/S 8509, 8506, 8511, 8512, 8513 + Mod.B

ULEAC, Syllabuses 9020, 9021, 9022, 9023, 9024, 9025, 9026, 9027, 9028, A/S 8020

Northern Examinations and Assessment Board (NEAB)

Northern Ireland Schools Examinations Assessment Council (NISEAC)

OXFORD, Syllabus 9894

OX/CAM, Syllabus 9642

Scottish Examinations Board (SEB)

Welsh Joint Education Committee (WJEC)

	Mand	Mark	WP	Dis	PQ	Des
AEB 0603	Yes	33%	1 x 3 hrs	-	Yes	No
AEB 0605	No	33%	1 x 3 hrs	-	-	Yes
CAMB 9309	Yes	30%	-	5,000 *	-	Yes
CAMB 9302	Yes	30%	-	5,000 *	-	Yes
CAMB 9304	Yes	30%	-	5,000 *	-	Yes
CAMB 9317	Yes	30%	-	5,000 *	-	Yes
CAMB 9322	Yes	30%	-	5,000 *	-	Yes
CAMB Mod.B	Yes	33%	-	5,000 *	-	Yes
CAMB (A/S) 8509	No	40%	-	3,000 *	-	Yes
CAMB (A/S) 8506	No	40%	-	3,000 *	-	Yes
CAMB (A/S) 8511	No	40%	-	3,000 *	-	Yes
CAMB (A/S) 8512	No	40%	-	3,000 *	-	Yes
CAMB (A/S) 8513	No	40%	-	3,000 *	-	Yes
CAMB (A/S) Mod.B	Yes	33%	-	2,500 *	-	Yes
ULEAC 9020	Yes	-	1 x 3 hrs (opt)	3,000/6,000	Yes	Yes
ULEAC 9021	Yes	-	-	3,000/6,000	-	Yes
ULEAC 9022	Yes	-	-	3,000/6,000	-	Yes
ULEAC 9023	Yes	-	-	3,000/6,000	-	Yes
ULEAC 9024	Yes	-	-	3,000/6,000	-	Yes
ULEAC 9025	Yes	-	-	3,000/6,000	-	Yes
ULEAC 9026	Yes	-	-	3,000/6,000	-	Yes
ULEAC 9027	Yes	-	1 x 3 hrs	3,000/6,000	Yes	Yes

	Mand	Mark	WP	Dis	PQ	Des
ULEAC 9028	No	-	1 x 3 hrs (opt)	-	Yes	Yes
ULEAC (A/S) 8020	Yes	-	-	2,000/3,000	-	Yes
NEAB	Yes	30%	-	3,000/4,500 *	-	Yes
NEAB (A/S)	Yes	30%	1 x 3 hrs	-	-	Yes
NISEAC	Yes	15%	-	4,000	-	Yes
OXFORD 9894	Yes	20%	1 x 3 hrs	-	Yes	No
OX/CAM 9642	Yes	20%	-	3,000	-	Yes
OX/CAM 9644	No	33%	1 x 3 hrs (opt)	3,000	-	Yes
SEB (Higher G.)	Yes	27%	1 x 2 hrs	-	Yes	Yes
WJEC	Yes	25%	1 x 3 hrs (opt)	2,000/5,000 (opt)	Yes	Yes
WJEC (A/S)	Yes	30%	1 x 1 hr (opt)	1,000/2,500 (opt)	Yes	Yes

History of art in the Republic of Ireland

Leaving Certificate – Ordinary and Higher Level

The history and appreciation of art is a mandatory element in these examinations and attracts 37.5% of the overall mark. There is a 2½-hour examination paper in which candidates should answer one question from each of the three sections listed below:

Section I: Art in Ireland (from prehistoric times to the present)

Section II: European art (from AD 1000 to the present)

Section III: General appreciation (an opportunity to discuss topics based on everyday visual experience in candidates' own environment)

Appendix III

History of Art Topics Specified in Advanced and Advanced Supplementary Level Syllabuses

Every effort has been made to ensure that the following summary of requirements is correct at the time of going to press. However, candidates should check by asking their teacher and looking at the appropriate syllabus before starting work.

Key to abbreviations used:

a	=	Architecture
d	=	Design (used here to signify product design, etc)
m	=	Minor arts (used here to signify furniture, jewelry, metalwork, pottery, stained glass, etc)
Mand	=	Mandatory
Opt	=	Optional or option no.
P	=	Paper
p	=	Painting
s	=	Sculpture
*	=	Topic changed on a yearly or two-yearly basis

The abbreviations used for exam boards are as specified on pp. 176–77.

A-Level history of art

Chronological summary of topics available

Pre-Classical and non-Western cultures (CAMB P1 Opt A)

Ancient Greece to the early Christian period a m p s (CAMB P1 Opt B)

Medieval Europe a m p s, c. 780–1250 (ULEAC P2 Opt 1)

Medieval Britain a m p s Anglo-Saxon period to c. 1200 (ULEAC P1 Opt 1)

Medieval Europe and the British Isles a m p s to c. 1300 (CAMB P1 Opt C)

Romanesque in Normandy and England a (OX/CAM Mand P2 i; OX/CAM (A/S) Opt)

Late medieval Italy m p s (OX/CAM P1 Opt 1; OX/CAM (A/S) Opt)

Gothic in the Île de France and England (OX/CAM Mand P2 ii; OX/CAM (A/S) Opt)

Gothic in Britain a m p s, c. 1200–1500 (ULEAC P1 Opt 2)

Later Gothic a in Britain (OX/CAM P2 Opt 1; OX/CAM (A/S) Opt)

Europe a m p s 1300–1500 (CAMB P1 Opt D)

Early Renaissance a in Italy (OX/CAM Mand P2 iii); a m p s (AEB P1 Opt 3)

Renaissance in Italy p s 15th-century (OX/CAM Mand P1 i; OX/CAM (A/S) Opt)

Renaissance in northern Europe p s (OX/CAM Mand P1 ii; OX/CAM (A/S) Opt)

European Renaissance a m p s 1300–1600 (ULEAC P2 Opt 2)

Europe a p s 1250–1770 (OXF Mand P1 Opt A)

Europe a m p s 1500–1700 (CAMB P1 Opt E)

High Renaissance in Italy p s (OX/CAM Mand P1 iii; OX/CAM (A/S) Opt)

High Renaissance in Italy a (OX/CAM Mand P2 iv; OX/CAM (A/S) Opt)

High and Late Renaissance in Italy and Spain a p s (AEB P1 Opt 4)

Venetian Renaissance p (OXF P2 Opt 8*)

Great Venetian painters 16th century (OX/CAM Mand P1 iv; OX/CAM (A/S) Opt)

Birth of Roman Baroque p s 17th century (OX/CAM Mand P1 v; OX/CAM (A/S) Opt)

Roman Baroque a (OX/CAM Mand P2 v; OX/CAM (A/S) Opt)

French Classical a 1625–1700 (OX/CAM P2 Opt 2; OX/CAM (A/S) Opt)

The Golden Age of Dutch painting (OX/CAM P1 Opt 2; OX/CAM (A/S) Opt)

Britain p s from Elizabeth I to George IV (ULEAC P1 Opt 3)

English house 1680–1770 (OX/CAM P2 Opt 4; OX/CAM (A/S) Opt)

English country house 1600–1850 (OXF P2 Opt 3*)

Architecture in Britain c. 1616–1836 (ULEAC P1 Opt 4)

English Baroque a (OX/CAM P2 Opt 3; OX/CAM (A/S) Opt)

Italian Baroque a m p s (OXF P2 Opt 6)

Palladian revival (OX/CAM P2 Opt 5; OX/CAM (A/S) Opt)

Europe a d p s 1700–1900 (CAMB P1 Opt F)

Landscape painting in Britain (ULEAC P1 Opt 5)

English landscape painting and European background, 1600–1850 (OX/CAM P1 Opt 3;
 OX/CAM (A/S) Opt)

International Neoclassicism a (OX/CAM P2 Opt 6; OX/CAM (A/S) Opt)

Europe a p s 17th century (ULEAC P2 Opt 3)

Neoclassicism, the Romantic movement and Realism a m p s (AEB P1 Opt 8)

Europe, Rococo and Revolutions a m p s (ULEAC P2 Opt 4)

Romantic painting (OX/CAM P1 Opt 4; OX/CAM (A/S) Opt)

Europe and North America a p s 1771–present (OXF Mand P1 B)

Europe a d m p s, c. 1848–1914 (ULEAC P2 Opt 5)

Three Victorian architects (OX/CAM P1 Opt 7; OX/CAM (A/S) Opt)

Impressionists (OX/CAM P1 Opt 5; OX/CAM (A/S) Opt)

European Post-Impressionism p (OXF P2 Opt 1*)

European Expressionism p s 1885–1925 (OXF P2 Opt 2*)

The West a d m p s 1848–present (CAMB (A/S) P1 Opt G)

Twentieth century a d m p s (ULEAC P1 Opt 6)

Art Nouveau and Art Deco a p s (OXF P2 Opt 5*)

Modern art and its origins a p s (AEB P1 Opt 9)

Western a d m p s since 1900 (CAM Mand P2)

European a d m p s 20th century (ULEAC P2 Opt 6)

Aspects of 20th-century painting (OX/CAM P1 Opt 7; OX/CAM A/S Opt)

English art and Modernism (OXF P2 Opt 7*)

Modern Movement a 1910–39 (OX/CAM P2 Opt 8; OX/CAM (A/S) Opt)

Modern sculpture 1900–70 (OX/CAM P1 Opt 8; OX/CAM (A/S) Opt)

Pop Art in Europe and America (OXF P2 Opt 4*)

General paper (including questions on social aspects, etc) (AEB)

A-Level art and design with mandatory or optional art history component
Chronological summary of topics available

Greek and Roman a s (ULEAC P71 Opt 1)

Celtic and Medieval Britain (WJEC)

Romanesque 7th–12th century (NEAB Sec A Opt 4)

Gothic in England and France a m s (ULEAC P71 Opt 2)

English Medieval a 1066–1550 (OXF P1 Sec 1 Opt 1)

Italy and northern Europe p s, c. 1300–1520 (ULEAC P72 Opt 8)

European and British Renaissance d p s (WJEC)

Renaissance Italy a, c. 1400–1600 (ULEAC P71 Opt 3)

Italy and northern Europe p s, c. 1470–1600 (ULEAC P72 Opt 9)

Italian p 15th and 16th centuries (OXF P1 Sec 2 Opt 2)

British p, c. 1530–1800 (ULEAC P72 Opt 11)

European and British Baroque a d p s (WJEC)

Baroque in Western Europe (NEAB Sec B Opt 3)

Europe p 17th century (OXF P1 Sec 2 Opt 3)

Europe p s 17th century (ULEAC P72 Opt 10)

England a 1550–present (OXF P1 Sec 1 Opt 2)

England p 1700–1850 (OXF P1 Sec 2 Opt 4)

Britain, Italy, France and Spain p, c. 1700–1870 (ULEAC P72 Opt 12)

Europe and Britain a d p s, c. 1780–1900 (WJEC)

The West a d p s 1750–present (SEB)

Europe p 18th–19th century (OXF P1 Sec 2 Opt 5)

Europe p s, c. 1860–1914 (ULEAC P72 Opt 13)

Britain a 17th and 18th centuries (ULEAC P71 Opt 4)

Europe a d m 19th century (ULEAC P71 Opt 5)

Arts and Crafts movement (NEAB Sec B Opt 5)

Impressionism and Post-Impressionism (NEAB Sec A Opt 5)

Europe and America a d 20th century (ULEAC P71 Opt 6)

Europe and America p s since 1914 (ULEAC P72 Opt 14)

Europe p 20th century (OXF P1 Sec 2 Opt 6)

The Modern Movement a (NEAB Sec A Opt 9)

The modern world, Europe and America (WJEC)

America p s since 1940 (NEAB Sec A Opt 4)

Art movements since 1945 (NEAB Sec A Opt 7)

Buildings for leisure 1850–1990 (NEAB Sec B Opt 7)

Bauhaus (NEAB Sec B Opt 8)

Public architecture of the last twenty years (NEAB Sec A Opt 10)

Industrial design 20th century (NEAB Sec C Opt 4)

Media and new technology (NEAB Sec C Opt 7)

Photography, cinema and television (NEAB Sec C Opt 10)

Islamic and Oriental a d (ULEAC P71 Opt 7)

African and Oriental art from the 14th century (ULEAC P72 Opt 15)

Indian art 3rd century BC–18th century AD (ULEAC P72 Opt 15)

Chinese p 7th–17th century (ULEAC P72 Opt 15)

Japanese art 15th–19th century (ULEAC P72 Opt 15)

General and unspecified with picture question(s) (AEB 0603 P2 & 0605 P2 Opt 25)

General (ULEAC P71 & P72; WJEC)

Note: NEAB includes seventeen general options in its A/S paper

Appendix IV
A Selection of Museums, Galleries and Useful Addresses

A much fuller list will be found in *Museums and Galleries in Great Britain and Ireland* (an annual publication listing most permanent collections, temporary exhibitions and a guide to subjects), Reed Information Services, Windsor Court, East Grinstead House, East Grinstead, West Sussex, RH19 1XA. Also very helpful is *The Art Galleries of Britain and Ireland: A Guide to their Collections* (1985) by Joan Abse. *A Directory of Arts Centres in England, Scotland and Wales* is published by the Arts Council of Great Britain. The Arts Council, based at 105 Piccadilly, London, W1V 0AU, will also supply information about current and forthcoming exhibitions.

Most of the larger galleries and museums have education departments. Perhaps the most comprehensive and advanced service is that provided by the National Gallery, London. Here there are talks, conducted tours, lectures, study days, competitions, videos and a highly sophisticated Computer Information Room with twelve work stations. All these services are free. For those A-Level students who are able to visit London's Tate Gallery there are 'surgery' sessions to help with the planning and researching of personal studies and dissertations. In addition, the gallery offers study days when students have the opportunity to investigate a range of artworks with the help of artists, art historians and the Tate staff.

Aberdeen:	Aberdeen Art Gallery, Schoolhill.
Barnard Castle:	The Bowes Museum.
Bath:	Museum of Costume, Assembly Rooms.
	Victoria Art Gallery, Bridge Street.
Birmingham:	Birmingham Museum and Art Gallery, Chamberlain Square.
	Barber Institute of Fine Arts, University of Birmingham.
Bristol:	Arnolfini Gallery, 16 Narrow Quay.
	The City Museum and Art Gallery, Queens Road.
Cambridge:	Fitzwilliam Museum, Trumpington Street.
	Kettle's Yard (University of Cambridge), Northampton Street.
Cardiff:	The National Museum of Wales, Cathays Park.
Cheltenham:	Cheltenham Art Gallery and Museum, Clarence Street.
Chichester:	Pallant House Gallery, 9 North Pallant.
Cookham-on-Thames:	Stanley Spencer Gallery, King's Hall.
Dublin:	National Gallery of Ireland, Merrion Square (West).
	National Museum of Ireland.

Edinburgh:	National Gallery of Scotland, The Mound.
	Scottish National Gallery of Modern Art, Belford Road.
Glasgow:	Art Gallery and Museum, Kelvingrove.
	The Burrell Collection, Pollok County Park.
	Hunterian Art Gallery (Glasgow University), Hillhead Street.
Leeds:	City Art Gallery, Municipal Buildings.
Leicester:	The Leicestershire Museum and Art Gallery, New Walk.
Liverpool:	Tate Gallery Liverpool, Albert Dock.
	Walker Art Gallery, William Brown Street.
London:	British Museum, Great Russell Street.
	Courtauld Institute Galleries, Somerset House, The Strand.
	The Crafts Council, 12 Waterloo Place.
	Design Museum, Butler's Wharf, 28 Shad Thames.
	Kenwood – The Iveagh Bequest (English Heritage), Hampstead Lane.
	Dulwich Picture Gallery, College Road.
	Hampton Court Palace, Hampton Court, East Molesey, Surrey.
	Hayward Gallery, South Bank Centre (Arts Council), Belvedere Road, South Bank.
	Institute of Contemporary Arts, Nash House, The Mall.
	National Gallery, Trafalgar Square.
	National Portrait Gallery, St Martin's Place, Trafalgar Square.
	Royal Academy of Arts, Piccadilly.
	Royal Institute of British Architects, 66 Portland Place.
	Royal Society of Painter-Etchers and Engravers, Bankside Gallery, 48 Hopton Street, Blackfriars.
	Sir John Soane's Museum, 13 Lincoln's Inn Fields.
	Tate Gallery, Millbank.
	Victoria and Albert Museum, Cromwell Road, South Kensington.
	Wallace Collection, Hertford House, Manchester Square.
	Whitechapel Art Gallery, 80–82 Whitechapel High Street.
	William Morris Gallery. Water House, Lloyd Park, Forest Road, Walthamstow.
Manchester:	Athenaeum Gallery, Princes Street.
	City Art Gallery, Mosley Street.
	Whitworth Art Gallery (University of Manchester), Oxford Road.
Newcastle-upon-Tyne:	Laing Art Gallery and Museum, Higham Place.
Norwich:	Norwich Castle Museum (Norfolk Museums Service).

	Sainsbury Centre for Visual Arts, University of East Anglia.
Oxford:	The Ashmolean Museum of Art and Archaeology, Beaumont Street.
	Museum of Modern Art, 30 Pembroke Street.
Port Sunlight:	The Lady Lever Gallery.
St Ives:	Tate Gallery St Ives, Porthmeor Beach.
	The Barbara Hepworth Museum, Barnoon Hill.
Salford:	Museum and Art Gallery, The Crescent, Peel Park.
Sheffield:	Graves Art Gallery, Surrey Street.
	Mappin Art Gallery, Weston Park.
Southampton:	Southampton City Art Gallery, Civic Centre.
Sudbury:	Gainsborough's House, 46 Gainsborough Street.
Wakefield:	Yorkshire Sculpture Park, Bretton Hall, near Wakefield.
Worcester:	The Dyson Perrins Museum of Worcester Porcelain, Severn Street.
York:	York City Art Gallery, Exhibition Square.
	York Castle Museum, Eye of York.

	600BC	500	400	300	200	100	0	100AD	200	3
							Landscape from Pompeii		'Christos Helios' mosaic, Rome	
A CONCEPTUAL ART	Kouros of Sounion	Kritian Boy								
COLOURED								Mummy-case portrait from Fayum		
& THE APPLIED ARTS	Temple of Hera I, Paestum					Maison Carrée, Nimes	Pantheon, Rome		Arch Constan Rom	
	Amphora by Exekias		Flagon from Basse-Yutz	Witham shield						

400	500	600	700	800	900	1000
Mosaic, Galla Placidia, Ravenna	'Vienna Genesis'			The Book of Kells	Paris Psalter	Lectionary of Henry II
	Transfiguration mosaic, Mt Sinai			Utrecht Psalter	New Minster Charter	
Buddha from Sarnath			Great Mosque, Cordova			
Sta Maria Maggiore, Rome			All Saints, Brixworth — Palace Chapel, Aachen		St Philibert, Tournus	
	Maximian's Chair		The Franks Casket			

	1100AD	1200	1300	1400	1500
	Christ in Majesty, Berzé-la-Ville	Chichester Roundel	Duccio Giotto	*Très Riches Heures* Masaccio R. van der Weyden Piero della Francesca H. van der Goes Leonardo da Vinci Dürer Bellini Altdorfer	Titian Tintoretto P. Bruegel the El El Gre Carava
		N. Pisano		Donatello	Cellini Michelangelo
	Masjid-i-Jami, Isfahan	Chacmool	Illustrated Koran		Stone of Tizoc *Khamsa* of Nizami
	Sainte-Foi, Conques S. Marco, Venice	Fontenay Abbey Trinity Chapel, Canterbury	Rheims Cathedral	The Octagon, Ely Cathedral	King's College Chapel, Cambridge Palladio
		Reliquary from Hochelten			

Rembrandt

Velázquez Reynolds
David Cotman
Constable
J. van Ruisdael Géricault
Blake
Fragonard Turner
Millais
ubens Goya Courbet
Monet
Poussin Cézanne Pollock
Van Gogh Bacon
Manguin
Sickert

Bernini Rodin Moore Long
Doherty
Hirst

barnāmeh Hiroshige
Ching-te Chen vase Luba headrest
Navajo
dry painting

o Jones Vanbrugh Soufflot Paxton Graves
R. Adam Adler and Foster
Sullivan
Mackintosh

Kändler Clarice Cliff
Directoire style Dreyfuss
Barouche by Hallmarke D'Ascanio
and Aldebert
Dr Martens
boots

| 1700 | 1800 | 1900 | 2000 |

Illustration Credits

Index

Index